Digital
Photography

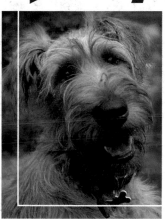

Digital
Photography

Mike Hemsley fbipp

How to take, manipulate
and print great digital
photographs

This is a Parragon Book
First published in 2006

Parragon
Queen Street House
4 Queen Street
Bath BA1 1HE, UK

ISBN 1-40547-112-3

Printed in China

Produced by terryjeavons&company
Cover designed by Talking Design

Contents

1

Digital Photography Today

006-013

Introduction

Whenever we witness advances in technology and communication, we also witness inevitable change that can influence our work and pleasure time, or change the way in which we interact with each other. You might take this as a reference to mobile phones, personal computers, digital television or even the Internet, but here I'm referring to that 175-year-old process, photography.

Technological advances have forced the world's photographic industries to examine existing markets and react to strong commercial pressures. The result has been a substitution of traditional analogue methods of capture (film) in favour of digital (sensors). The change has, however, almost exclusively been to your advantage. For you – the consumer – the competition between manufacturers has produced innovation, quality and choice in a wide range of digital-imaging products whose retail values have fallen at the release of each new model. Never again will you have to worry about spending money on a choice of film speed, colour negative or transparency to match lighting conditions – you simply won't need film at all! There continues to be commercial casualties along the way but one fact is clear, digital photography has finally come of age.

Digital cameras

The wide variety of digital cameras available today has empowered everyone to become a photographer. Pocket-sized digital camera phones provide instant transmittable records of breaking news events, while the physical size and weight of ultra-compact digital cameras make them ideal candid portrait tools. At the higher specification end, semi-professional (prosumer) fixed-lens and digital SLR (single-lens reflex) cameras deliver the standard that is now expected from hi-end digital technology in terms of file size and print quality. But perhaps more importantly, digital images can be modified easily using powerful image-editing software; it is this seductive feature that may divert many from the conventional methods of picture making.

Photography is FUN! The point of capture requires an instant creative decision that will involve choices in subject, composition and lighting. All are necessary considerations that should be made before embarking on any potentially complex image editing. Many years ago George Eastman famously said of his Kodak camera system, 'you press the button and we do the rest' – how times change. By their very nature digital cameras sport a range of buttons, dials and menus driven by graphic displays, which, unless you have the finger dexterity of a concert violinist, can seem off-putting. It is intended that this book should bring enjoyment to your digital photography by putting you at ease with the basic principles of digital image creation.

Photography, like other visual arts, has more to do with looking, seeing and understanding in order to realise an idea than simply spending time in correction, adjustment and retouching. It has been suggested that digital-image technology can turn a bad photograph into an acceptable photograph, and this is certainly possible. But why not aim higher! Through the pages of this book you should be inspired first to create a good image and then to fine-tune it into something you can be really proud of. Then you can decide whether to commit it to photographic or digital output, view it on a computer screen, or send it as an email to display your newly found talent to family and friends – no matter where in the world they live.

ABOVE **The consumer has a vast choice of digital cameras available for a range of budgets. To recognise the correct model for your own needs you should understand the level to which you want to take your interest in photography.**

Where Do You Start?

Before you buy a digital camera, you should first review the various ways in which a digital image can be captured. How and what you use to achieve your final result is up to you. There are no hard and fast rules in digital imaging as long as the end justifies the means. You might at first be persuaded into thinking that you need to spend a very large sum of money on the latest, highest-specification digital camera. This book, however, sets out to prove to you that

with a good knowledge of the basic techniques of photography it's possible to create wonderful images – even with a budget camera.

Cameras are tools for the job, each has its place and some can manage a task more easily than others – essentially the creative results are in your control. All you need is confidence in your decisions when taking photographs, and this can be boosted by the support and guidance found in the pages of this book – so let's get to work.

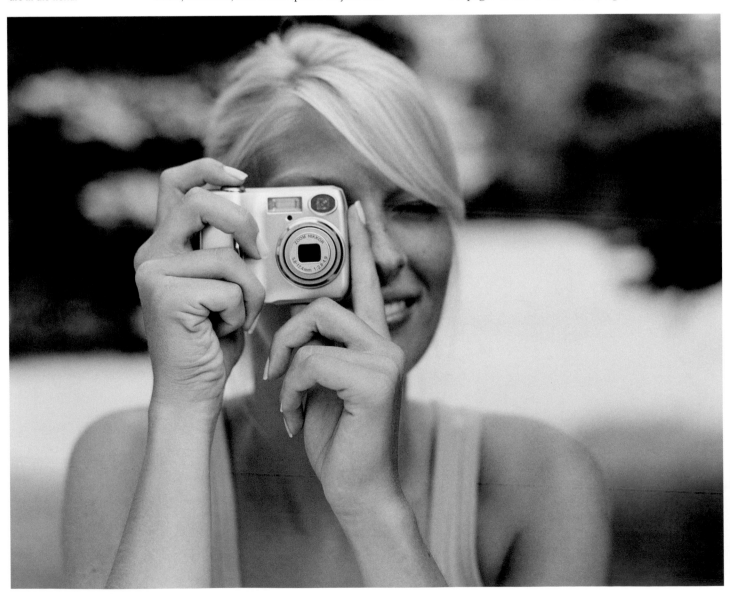

Film to digital option

Unexpectedly perhaps – for a digital photography book – if you have a conventional camera consider shooting with film and then ask your local mini-lab to scan the film or processed images to CD-ROM. This is an inexpensive and gradual introduction to digital imaging. Once the film images are digitally captured you are in exactly the same position as the digital camera user who has downloaded files from the camera onto a computer in order to manipulate them. Equally, old negatives and prints can also be scanned on a home flatbed or film scanner. You can then apply digital-retouching techniques to the scanned files to rescue lost or faded family pictures. Ideas like these, and the methods, are covered later in this book, but for now you should be considering all your options.

If you already own a digital camera you might be tempted to skip these early pages, but it can be useful to review just how and why you chose your particular model. By the time you reach the end of this section you should be able to recognise your niche and therefore what type of camera is really suited to your needs.

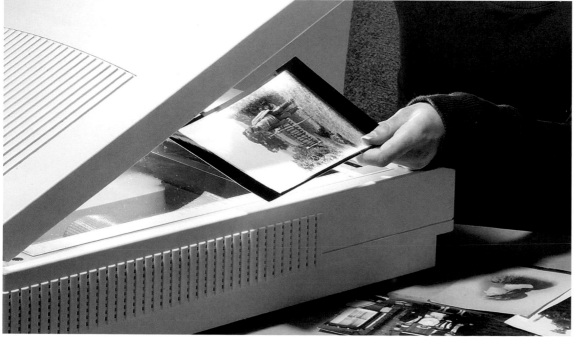

TOP LEFT AND ABOVE **Even if you don't own a digital camera or prefer to use your conventional film camera, you can easily get the film or prints scanned and burned onto a CD by your high-street photo-lab.**

LEFT **A scanner is a useful tool in the world of digital imaging, with many capable of scanning both film and existing photographs into your computer for archiving and restoration.**

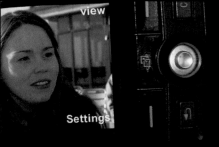

The Digital Camera Phone

Digital camera phones are popular fashion accessories, and the release of many new models on an almost monthly basis ensures this trend will continue. A compact, stylish multi-function device providing phone communication, photo/video recording and which fits neatly in the pocket might be an attractive option for the aspiring digital photographer. A positive aspect of this product is that it is carried about during the day and is there to take a photograph at a moment's notice.

The Internet is being showered with pictures from the daily lives of millions of camera phone users to document breaking news and live events. Sadly, however, many of the images produced using camera phones are of poor quality. The small size of a camera phone's image sensor ensures that the image resolution is suitable only for emailing to friends or for viewing on a computer screen. Attempting to print an image file from a camera phone, even at a relatively small size, will usually result in a poor-quality print. In part this is generally due to the fact that camera phone technology is still developing and dedicated camera features are limited.

BELOW **The quality of a mobile phone image is determined not only by the size of the image sensor, but also by factors such as the steadiness of your hand, brightness of the scene and accuracy of focus.**

Size matters

To achieve a better quality image, camera phones with 2-megapixel sensors and above are now emerging, and these will go some way to reducing the gap between camera phones and dedicated cameras. The implications of sensor size will be outlined later in this book, but remember, aside from technology, it is also often poor photographic technique by the photographer that results in poor-quality images.

You will find some useful tips and techniques later in the book to help you get the best results from your camera phone should you choose this as your preferred means of digital capture. The tips can only advise and will not ensure you achieve a razor-sharp image – as you will discover the best-quality digital images are delivered using a dedicated camera. It is generally true to assume that a multi-function device has a dominant feature in which it excels (as a phone) at the expense of other features (low-resolution stills or video). However, before tackling dedicated digital cameras, the next digital photo capture option you might consider is the DV movie camera.

A 640 x 480 pixel image capture, the phone supported for steadiness.

Whatever the device used to record an image, be creative in composition.

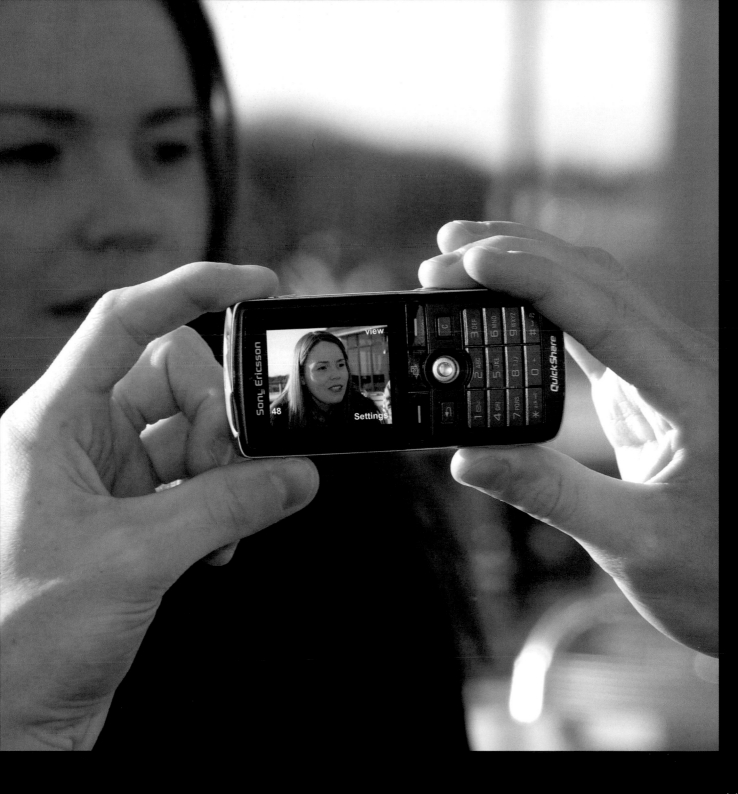

The Digital Video Camcorder

While camera phones presently provide limited multi-function options, some digital video camcorders sport an impressive specification for both video and stills capture. The two facilities are closely related to the quality of capture via the camcorder's CCD (charge-coupled device) sensor. In the budget range of DV camcorders a captured still image on a single CCD sensor hovers at around 640 x 480 pixels in size (or the equivalent of around 0.3-megapixels). This is on a par with many camera phones and would produce an acceptable photographic print no larger than 6.5 x 5 cm (2.5 x 2 in). In the more expensive DV models, where each colour is catered for with a separate CCD for red, green and blue channel combinations, a still image of up to 2560 x 1920 pixels is possible. This would achieve an impressive 25.5 x 20 cm (10 x 8 in) photographic or A4 inkjet print. A DV camcorder of this type also provides exceptionally high-quality video images that can be edited on a domestic home computer and then written to disc for DVD playback.

STORAGE AND PRINTING

Image storage varies between DV camcorders; some record the still image to a separate removable memory device while others commit an image directly to the DV tape, hard drive or DV disc.

Outputting the still image directly to print without the need of a computer is also possible on some camcorders because they use a feature called 'PictBridge'. This is a means of communication between a dedicated printer supporting PictBridge and the participating DV camera. Without this feature the video camera is similar to the stills camera in that a captured file is copied across (usually via a USB cable) onto the computer's hard drive where the image can be prepared for printing.

If you are as much a video enthusiast as you are a stills photographer then a DV camera with high-quality stills capture is a possibility. Higher-specification DV cameras, however, also come at a higher price; and if it's stills photography that you're primarily interested in, you're more likely to get better value for money as well as higher-quality images with a dedicated stills camera – simply because it is designed for the task.

RIGHT **A printer with PictBridge capability will be able to output a print from a camera without the need to connect via a computer. Popular with people whose expectations for a photograph do not go beyond the 'taking' stage and are happy with direct output from the camera image.**

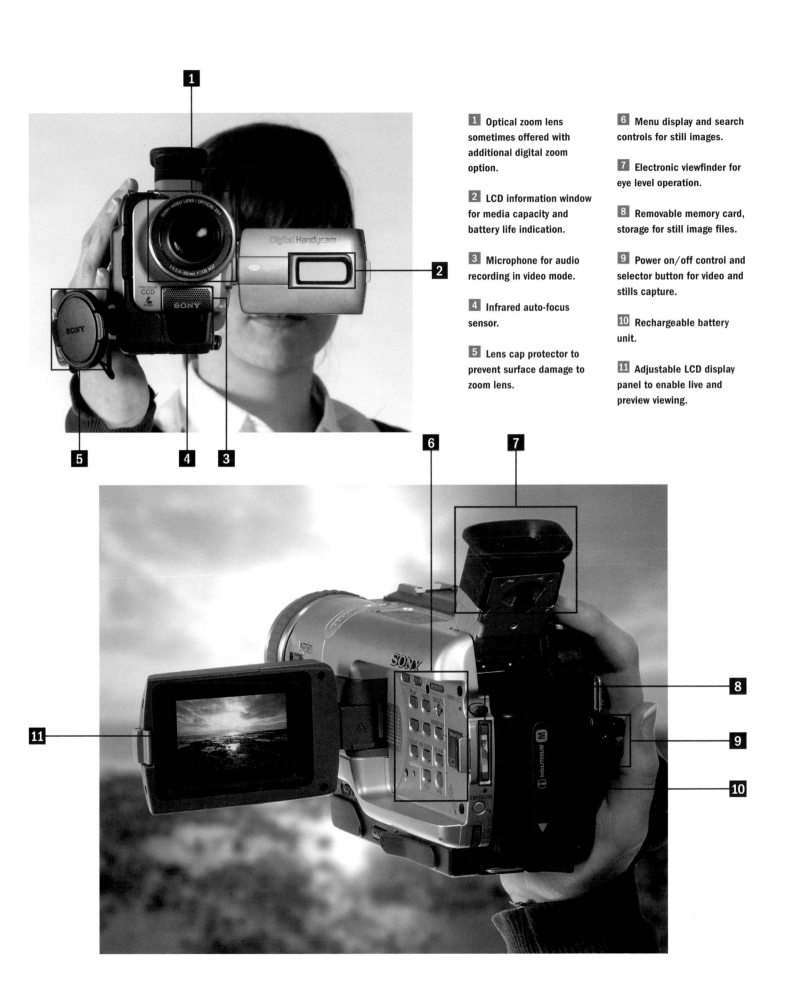

1 Optical zoom lens sometimes offered with additional digital zoom option.

2 LCD information window for media capacity and battery life indication.

3 Microphone for audio recording in video mode.

4 Infrared auto-focus sensor.

5 Lens cap protector to prevent surface damage to zoom lens.

6 Menu display and search controls for still images.

7 Electronic viewfinder for eye level operation.

8 Removable memory card, storage for still image files.

9 Power on/off control and selector button for video and stills capture.

10 Rechargeable battery unit.

11 Adjustable LCD display panel to enable live and preview viewing.

2

The Digital Camera

The Dedicated Digital Camera

O ver the next few pages we're going to examine the various dedicated digital cameras in terms of capability, complexity and cost. While you may be fortunate enough to afford the highest specification digital SLR available to date, your real needs might be catered for in a lesser model. This section looks at the budget range of cameras – those featuring sensors with up to 3 megapixels.

Sensor cost

There is a direct relationship between the size of a camera's image sensor and its cost. This is simply because high-quality images result from good lenses, a large sensor area on which to focus the image, and, as a consequence, a large number of pixels to record it on. It follows that a camera with say 2 megapixels will be considerably less expensive than a model returning 14 megapixels. The pixel count eventually determines the potential size of an output image and is relevant if you intend to greatly enlarge the results of your photography. If, however, you shot film in the past and never saw an image enlarged greater than a 13 x 18-cm (5 x 7-in) colour print why should you need to spend a large sum of money on a camera that can achieve 50 x 41-cm (20 x 16-in) colour prints?

The technology of digital photography will be explained more fully after this section on dedicated camera groups. For now your choice of camera is really determined by your photographic aspirations. The basic features found in some cameras can become a restriction if you want to do more than rely on automatic settings. Items to consider include the viewfinder, auto-exposure (AE), auto-focus (AF) and fixed focal length lenses or zoom lenses.

Seeing the limitations

Let's consider the first of these, viewfinders. With many budget cameras there is a short time delay between what you witness on the rear LCD screen and what the sensor is actually seeing. In the camera shop it might seem trivial – but try taking photos at a motor race or school sports day and you'll soon spot the problem. If the camera has a viewfinder it's easier to keep track of the moving subject. However, this won't necessarily help with the delay that can occur between pressing the shutter release and the camera taking the photo.

How a viewfinder works varies from camera type to camera type. With most entry-level cameras the viewfinder works entirely independently from the lens. If the lens has a zoom function, then the viewfinder will feature its own zoom that mirrors the lens' zoom action. In most cases this works fine, but remember your view is fractionally different from the lens' view.

Auto features

Budget cameras usually feature auto-exposure and auto-focus facilities that realease you from the need to make manual adjustments. You simply have to point the camera at your subject and press the button. The choice of exposure and point of focus is determined for you. This is a great feature if you primarily only take family and holiday snapshots and need to react quickly. However, you may soon find it restricting. Additionally, some budget compact cameras tend to have a fixed wide-angle lens (i.e. you can't optically zoom in to get closer to a subject) and a digital zoom feature (best left alone) that allows enlargement into the image sensor to emulate an optical zoom. This is not as good as an optical zoom (*see page 24*).

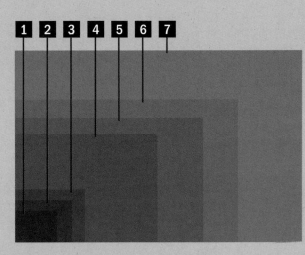

1 Ultra-Compact
5.27mm x 3.96mm

2 Midrange Compact
7.18mm x 5.27mm

3 Prosumer Compact
8.8mm x 6.6mm

4 4/3 System (Olympus E1)
18mm x 13.5mm

5 Nikon D1/D1h/D1x/D2h,
Fuji S1/S2
23.7mm x 15.5mm

6 Canon EOS 1D Mark II
28mm x 17.8mm

7 Canon EOS 1DS, Kodak
DCS Pro SLR/N
36mm x 24mm

ABOVE LEFT **This diagram clearly illustrates the difference in physical size between the sensors of various models of camera. The larger, full-frame (i.e. 35mm) sensors are found only in higher-end models.**

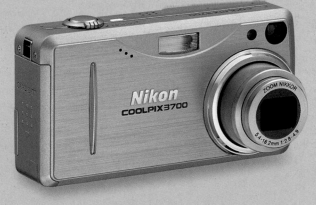

ABOVE **An example of a popular point-and-shoot camera featuring 3 megapixels. This camera's sensor falls into the ultra-compact sensor size (see chart, top left).**

The Dedicated Digital Camera

Prosumer and digital SLRs

These cameras are covered in the range of 5 megapixels and above, and perhaps more important than pixel count, offer manual control of most functions. All prosumer models have a fixed zoom lens, while SLRs have the ability to accept compatible lenses of various focal lengths. The advantage of a fixed zoom lens is that dust cannot enter the camera body and come to rest on the sensor when changing lenses. This does occur with SLR cameras, and manufacturers are looking at various ways to combat this. In digital photography a speck of dust on the sensor will be with you on each and every shot until you remove it!

Larger sensor area

Another important aspect of many prosumer and all digital SLRs is the large size of their image sensors. A large sensor will capture higher-quality images than the smaller sensors found in budget cameras, particularly in low-light conditions. How the sensor mosaic is arranged to capture an image also reflects in the colour quality and sharpness of an image. Manufacturers vary in their methods and these are discussed more fully in the book. A trade-off in higher quality is the larger file size generated when the image is saved. This results in a demand for larger camera memory, which is solved by allowing removable memory cards to be inserted into the camera to record the information. If you intend to print out your results to a size larger than A4 or 10 x 8 in then the 5-megapixel and above camera range is for you.

Viewfinders

As discussed earlier, it's so much easier to get the shot you want when viewing the scene through a viewfinder. Sports photography, wildlife, motor racing even the family dog can be framed and composed with ease.

Prosumer models have an electronic viewfinder (EVF). In effect this is a tiny LCD screen set in the eyepiece, which displays exactly the same image as the larger LCD screen on the back of the camera. These can work well, but are often quite dark, and will also suffer from the time lag problem explained earlier. By far the most satisfactory viewfinders are those found in digital SLR cameras. These are optical viewfinders, which, through a series of mirrors, display exactly what the sensor is 'seeing'. Because

RIGHT **The LCD screen, as well as showing a preview of the captured images, also provides the photographer with information about the image's exposure, and all the camera's settings and storage preferences.**

FAR RIGHT **Digital SLR cameras have the facility to accept compatible lenses of varying focal lengths. They also leave themselves vulnerable to dust entry. A good technique to minimise the chance of this happening is to point the camera body down and offer the lens up from below.**

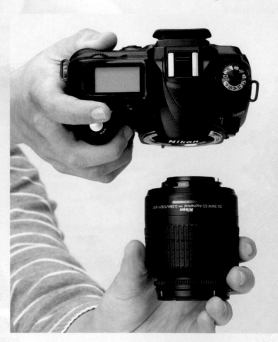

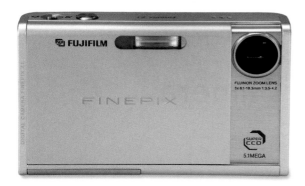

LEFT **The compact design of the Fuji FinePix Z1 disguises the fact that it is a 5.1-megapixel camera. The camera features a true optical zoom lens which emerges when the camera is activated. The viewfinder is replaced by a large LCD screen on the rear which has to be held away from the body in order to view the image.**

there are no electronics involved, it means there's no time lag. In addition, such viewfinders provide a clear bright image, which can help enormously when composing your shot.

Digital motor drive

On conventional film cameras it is possible to achieve many frames per second of continuous shooting. This is also true on some digital cameras. Continuous mode allows you to track moving subjects and then pick the best frame afterwards – ideal if your area of interest lies in sports or action photography. The semi-pro camera is capable of capturing fast frame rates at a reasonably high capture quality, although the very high image quality on some pro cameras limits the speed at which they can operate continuously.

Sophistication of control

The final consideration with prosumer and SLRs is their ability to release all the control back to you the photographer. Overriding the auto functions is part of the buzz experienced by the serious photographer because rules are there to be broken when image making is concerned. An auto-exposure function may force your shot into the sun to become a full silhouette when in fact you wanted shadow detail to be resolved. The rolling waves crashing onto the beach were frozen by the auto-shutter control when what you really wanted was a misty blur of motion created by a slower shutter speed. Frustrating for you if you have no control over the camera at all.

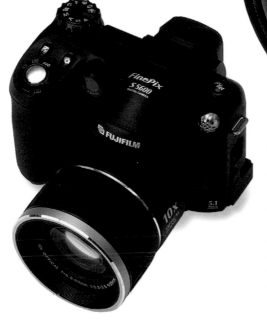

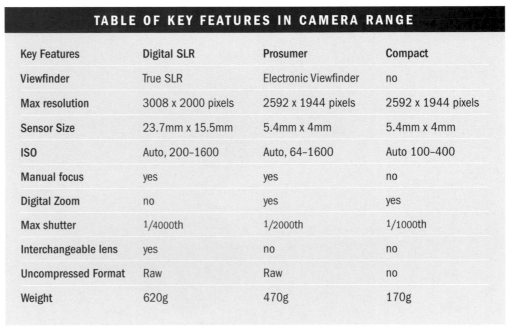

LEFT **The Fuji FinePix 5600 looks like a DSLR but in fact has an electronic viewfinder which contains a tiny LCD display. Its body is comfortable to hold, has a fixed zoom lens and mimics the appearance of the larger professional models made by FujiFilm.**

ABOVE **The Nikon D50 is an example of a true DSLR camera with a pentaprism (a series of mirrors) providing an optical view via an interchangeable lens. The ergonomic design is the product of earlier traditional film SLR cameras and is easy to hold and operate.**

TABLE OF KEY FEATURES IN CAMERA RANGE			
Key Features	Digital SLR	Prosumer	Compact
Viewfinder	True SLR	Electronic Viewfinder	no
Max resolution	3008 x 2000 pixels	2592 x 1944 pixels	2592 x 1944 pixels
Sensor Size	23.7mm x 15.5mm	5.4mm x 4mm	5.4mm x 4mm
ISO	Auto, 200–1600	Auto, 64–1600	Auto 100–400
Manual focus	yes	yes	no
Digital Zoom	no	yes	yes
Max shutter	1/4000th	1/2000th	1/1000th
Interchangeable lens	yes	no	no
Uncompressed Format	Raw	Raw	no
Weight	620g	470g	170g

Understanding the Camera

It's very tempting to rush out and start taking pictures straight away with your new digital camera on 'auto' setting. That thick, forbidding multi-language instruction book can be read at a later date, you tell yourself. But if some camera options are overlooked the creative potential available to you could be wasted! The answer is to read this chapter and learn about the functions of various parts of a modern digital camera. Then you can seek them out on your camera and experiment.

The Preparing to Shoot box below looks at some of the basic actions that should be considered by a photographer to capture an image successfully when the camera is set to manual mode.

At this point, some of you may be thinking it would be better to stick with the auto setting and not have to think about being in control. In certain circumstances this would be true, especially when taking 'grab' shots where to stop and make camera adjustments could result in missing the moment. However, by getting familiar with the various functions of a camera you will find that the hesitation and fumbling soon vanishes and concentrating on picture taking really begins. The reasons and methods behind the choice of shutter speed or exposure are explained more fully in this chapter, but identifying the camera controls should be your primary task.

PREPARING TO SHOOT

In preparing to take a digital image in manual mode there are certain key operations and decisions that have to be made before pressing the shutter release. Typically these considerations are:

- Select the camera's ISO setting (determined by circumstance – subject, light levels, etc.)
- Select a desirable shutter speed(determined by subject, light levels or creative preference)
- Balance the aperture setting to achieve correct exposure (shutter speed and aperture are closely related – one trading off against the other)
- Select an appropriate White Balance setting (controls the effect of unnatural-looking colour casts caused by colour-biased light sources)
- Take visual decisions to compose your subject through the viewfinder or LCD screen
- Check and adjust your point of focus
- Finally press the shutter release at the 'right' moment and take your picture

1 Main shutter release button and auto focus preview.

2 Lens hood preventing stray light to flare onto the lens.

3 Lens release button and locking switch for auto/manual focus.

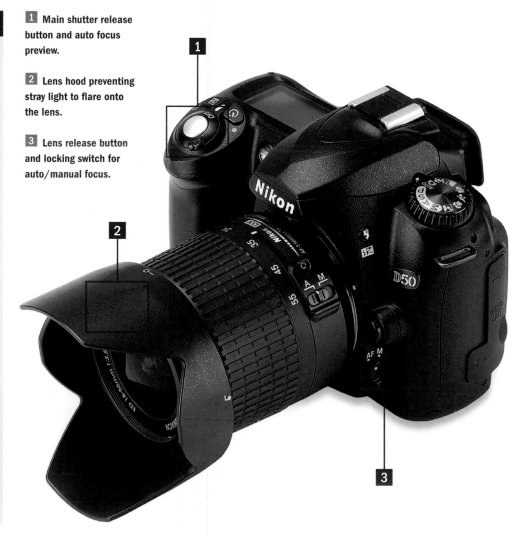

4 Indication of lens focal length settings in mm.

5 Main camera on/off switch.

6 LCD information panel detailing settings.

7 Flash Hot Shoe bracket.

8 Preset options and manual/auto override control.

9 Single/continuous shooting mode.

10 Auto-focus and auto-exposure lock button.

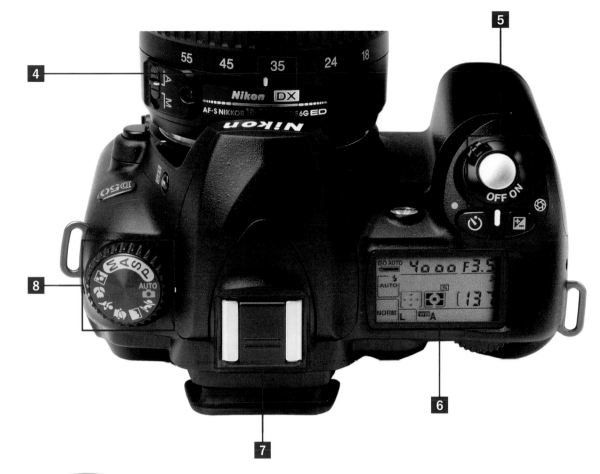

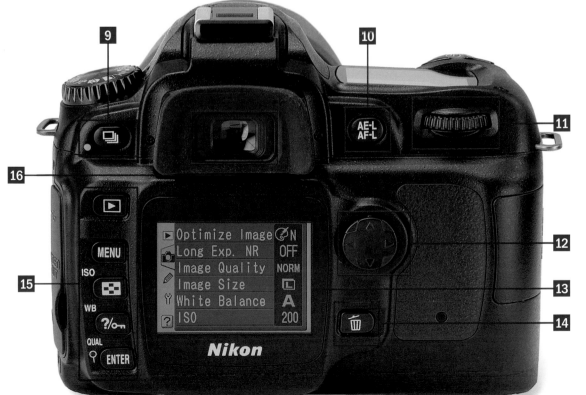

11 Settings selection thumbwheel.

12 Main menu navigation button.

13 Main LCD panel for viewing settings and images.

14 Image delete button.

15 Buttons controlling ISO, White Balance, image quality etc.

16 Optical viewfinder eyepiece.

How Digital Images are Captured

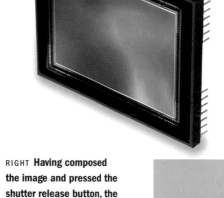

The image sensor

All digital cameras have an image sensor, and it is this 'chip' that replaces a conventional camera's roll of film. An image sensor consists of an array of millions of tiny electronic sensors onto which the lens focuses an image and where light is transformed into digital information. The sensor points are referred to as 'pixels', which is short for picture elements. To visualise their appearance, imagine an array with rows and columns arranged in the style of a computer spreadsheet. For instance a camera with an array of sensors in its CCD 3000 pixels wide and 2000 pixels high (3000 x 2000) will have a 6-megapixel rating. This rating is the factor most manufacturers emphasise to promote a specific digital camera – although you should also concern yourself with other issues such as the physical size of the sensor, the quality of the lens, and how easy the camera is to use.

Think big

Think of pixels as millions of points of light that are being stored for each picture. The more points of light there are, the higher the resolution of the image. So it follows that more pixels available results in potentially bigger pictures. Usually, the more megapixels the better! It takes a lot of megapixels to output prints onto photographic paper, so if you like big enlargements you should get a camera with as many megapixels as you can afford. However, although pixel count determines how large your prints can be, as we'll see later, it is not the overriding factor in image quality.

Converting your image into a digital signal

To capture a digital image, the focused image passes through red, green and blue colour filters – collectively known as the colour filter array (CFA) – positioned above the individual sensor. The sensor converts the image from light waves into an analogue signal. The analogue signal is then run

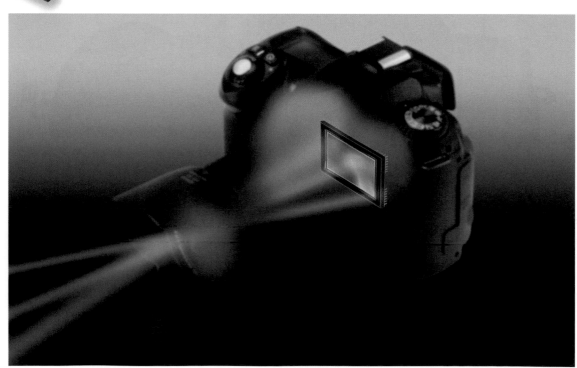

through an analogue to digital converter (A/D converter), where it emerges as a pure digital signal. This signal is then put through a series of internal electronic filters that adjust the white balance, colour, and sharpness of the image. Next, depending on the file format selected, the camera's software compresses the signal to make the image as small as possible by deleting unnecessary duplicated pixels and so deliver more efficient storage. With the process complete, the camera holds a compressed, filtered, digital signal that represents your image.

Buffer memory

Your image is then held in a temporary storage area inside the camera called buffer memory. When this buffer is full, the image is written out to your storage media, such as a removable memory card. The buffer size in the camera is important and effects the camera's efficiency. The buffer decides how many images the camera can take in quick succession. So if you own an inexpensive camera with a small buffer memory you will have to wait a moment or two for it to transfer existing files to the memory card before allowing you to continue to capture new images.

The LCD Display Screen

One of the major practical advantages of digital photography over conventional is that with digital photography an instant preview is available seconds after taking a picture. This provides the chance to review the shot and if necessary take it again. In practice this tempts photographers into carefully checking the LCD preview after every shot to see if all is well. This habit, however, slows down picture taking, which is fine if you are shooting landscapes, but with subjects such as people or wildlife you could be looking away from the action and missing other shots.

Seeing 2D

Photography is a translation of the three-dimensional world into a two-dimensional form, and a good photographer has the vision to achieve this. The LCD camera screen presents the final result for us in two-dimensions enabling anyone to spot a good shot. Sometimes we can be pleasantly surprised by the result, other times a quick press of the 'delete' button rids us of an image we'd rather

forget. However, be careful not to be too hasty because an image on the LCD screen is a 'proof' image and does not fully display the detail and colour fidelity of the final image. It is not uncommon to revisit a photograph taken some while back and find that it has more potential than was recognised originally. Displays such as the histogram should be treated as the accurate measurement of exposure rather than mere visual judgement based upon the screen.

The display screen can be used on most fixed-lens digital cameras as a live preview of the camera image when in 'capture mode'. The camera tends to be held out at arms' length – a technique that may prove to be uncomfortable for some people (for your arms or your eyes!). The viewfinder found on most cameras is more satisfactory, because you hold the camera to your eye like a rifle sight, making it easier to track the subject.

BELOW **The ability to review images as they are taken is a key feature of digital imaging. For accurate assessment of exposure, however, it is wiser to judge the image by its histogram (a graphic representation of the image's exposure) than base decisions purely on the LCD preview image.**

Camera Memory

In many ways a camera's removable memory card is to a digital camera what film is to a conventional camera. While some budget cameras have 'built-in' memory, removable memory cards are more practical because they usually have greater capacity, and provided you own enough of them, they offer you virtually unlimited shooting power – a far cry from the days of film.

Memory cards retain their information even when the power is turned off. Consequently they can be inserted into the camera just like normal film and when full can be used to transfer the acquired digital images directly to a compatible printer or to a home computer for editing and printing. As soon as the images have been downloaded from the card onto a computer the images can be erased and the card used again. If you want to archive your image data permanently – and I strongly advise that you do – you can either use a CD writer to burn a CD of your images once you've copied them over to

your computer or, alternatively, take the card to your local photo-lab to have prints made while at the same time asking for a CD to be written with your images.

Every digital camera is designed to take a specific storage system and can usually – given a few exceptions – only accept one or two types of memory card. To date six main types are competing for your attention.

COMPACTFLASH CARDS are the most popular having, uniquely, not only the storage module but also their own electronic controller to inform the camera what capacity they have and how they save the data. This has the advantage that the cameras are automatically kept in step with the steadily increasing size of CompactFlash cards. To date, it's possible to get a whopping 12Gb CompactFlash card – although this runs to many thousands of pounds and is far too large for most purposes.

RIGHT **Camera memory is removable and transportable. It is the ideal medium to download from at a high-street mini-lab or supermarket kiosk in order to purchase quality colour prints.**

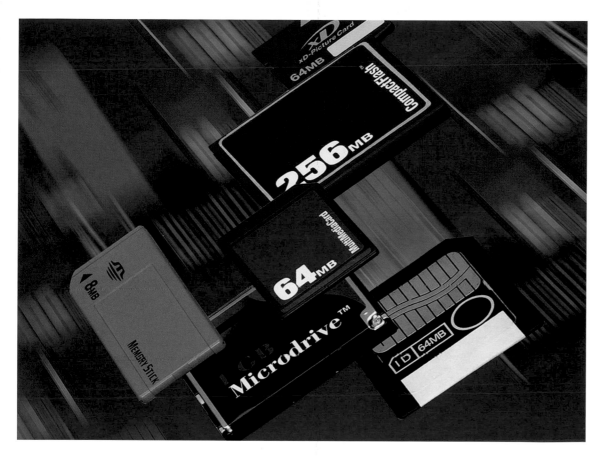

LEFT **A popular selection of camera media cards used to store digital camera images. They should be reformatted from time to time to optimise efficiency, and purchasing a data rescue program is recommended to salvage images from unexpected card failures.**

BELOW **A lockable door in the camera body usually opens to allow the removal of your camera's memory. Because of their small size the cards can require nimble fingers to remove them; furthermore, take care to avoid damaging the camera's memory slot door hinge.**

SECURE DIGITAL (SD) CARDS are becoming increasingly popular. They allow for rapid data transfer and feature a write-protection switch that will stop you accidentally deleting your image data.

MULTIMEDIA (MM) CARDS have the same surface area as SD cards, but are slightly thinner. Most cameras that accept SD cards also accept MM cards.

XD CARDS are the smallest of all the storage cards. They are designed to fit into the increasingly small ultra-compact digital cameras.

THE MEMORY STICK is a memory card created by Sony. A controller of its own is included in the system, but the physical design is completely different yet again. Memory Sticks do have the advantage that they can be exchanged between almost every new piece of Sony equipment – from MP3 players to camcorders and digital organisers.

SMARTMEDIA CARDS were once a popular storage type. However, unlike CompactFlash cards they don't have their own 'intelligence', and in most cases cameras with SmartMedia cards can only use the media up to a specifically set memory size – currently 128Mb. For this reason few new digital cameras now accept SmartMedia cards.

You may come across other storage methods that may be unique to a specific product or specialist market, but the six memory systems outlined form the choice for most digital photographers.

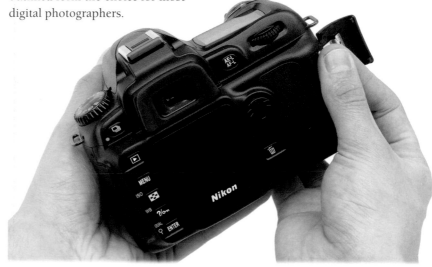

The Camera's Lens

BELOW **Architectural subjects require the use of a wide-angle lens to cover the scene. Such a wide field of view is equally necessary in small confined areas to maximise what would otherwise be a restricted view on a standard lens.**

The function of a digital camera lens is to gather the available light from the scene and focus it onto the image sensor. The significant difference between the typical digital camera lens and that of a 35mm film camera is the focal length.

Focal length

The focal length is the measurement between the lens and the surface of the sensor. The surface of the traditional film plane is much larger than the typical surface of most CCD sensors; in fact, a 1.3-megapixel digital sensor is usually approximately one-sixth of the dimensions of a frame of film. It follows that in order to project the image onto a smaller sensor, it is necessary to shorten the focal length by the same proportion. This explains why digital camera bodies and their zooms can be so much smaller than film cameras.

Focal length determines how much magnification you get when you look through your camera. In 35mm cameras, a 50mm (standard) lens gives a natural, eye view of the subject. As you increase the focal length (zoom in), you see greater magnification and objects appear to get closer. As you decrease the focal length (by using a wide-angle lens), objects appear to get farther away, but you can capture a wider field of view in the camera.

Because so many photographers used film-based cameras and were familiar with the standards of focal length that projected an image onto 35mm film, digital cameras quote their focal lengths with '35mm equivalents'. In the chart below, you can compare the actual focal lengths of a typical entry-level 1.3-megapixel camera and compare its equivalent in a 35mm camera.

Optical zoom vs. digital zoom

A zoom lens is defined as any lens that has an adjustable focal length, and there is a variety for you to choose from. Some digital cameras have fixed zoom lenses and it is important to establish the limitations of the optics before purchasing. A digital SLR body will allow interchangeable lenses and the chance to extend the viewing range from fish eye to extremely long focal length. As you can see in the chart below, the 'normal lens' view of the world for this particular 1.3-megapixel camera is 7.7 mm. You can zoom out for a wide-angle view, or you can zoom in for a closer view. Digital cameras may have an optical zoom, a digital zoom, or both; it's worth noting the difference.

An optical zoom actually changes the focal length of your lens. As a result, the image is magnified by the optics, hence the term 'optical' zoom. With greater magnification, the light is focused across the entire CCD sensor and all of the pixels are used. You should think, therefore, of an optical zoom as a true zoom that will place the magnified image onto the camera's sensor. A digital zoom works in a very different way.

FOCAL LENGTH COMPARISON

Focal Length	35mm Equivalent	View	Typical Uses
5.4mm	35mm	Objects look smaller and further away	Wide-angle shots, landscapes, large buildings, groups of people
7.7mm	50mm	Objects look about the same distance as our own viewpoint	'Normal' interaction shots of people and objects
16.2mm	105mm	Objects are magnified and appear closer	Telephoto shots, close-ups

200mm focal length

150mm focal length

105mm focal length

70mm focal length

55mm focal length

45mm focal length

35mm focal length

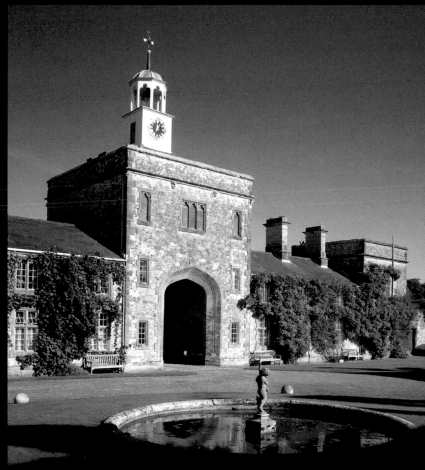

A digital zoom is provided as a feature simply because it's technologically possible. It works by magnifying just a portion of the information that hits your sensor. For instance, imagine you are shooting a picture with a 2x digital zoom. The camera will use only half of the available pixels in the centre of the CCD sensor and ignore all the other pixels. Then it uses computer interpolation techniques to add detail to the photo. It may look as though you are shooting a picture with twice the magnification but you should be aware that you can get the same results (or even better) by shooting the photo with the digital zoom turned off and blowing up the picture later, using image-editing software on a computer. A dedicated camera that only offers a digital zoom facility should be seen as having distinct limitations for picture making. Understandably, a mobile camera phone would be hard pressed to incorporate an optical zoom arrangement because of size constraints.

24mm focal length

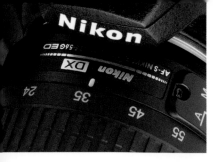

Understanding Depth of Field

The final appearance of your subject in a photograph can turn out to be quite different from the way you saw it when you took the picture. Usually when you look at a scene with your eyes, everything in it seems more or less equally sharp, but sometimes when you view the finished shot only part of the scene appears to be acceptably sharp.

Depth of field

If this has happened you have just witnessed a focusing effect called depth of field. The boundaries of depth of field (i.e. that region of the image that is sharply focused) are in front of and behind the point that you actually focused the camera on. What affects this range of focus is determined by the aperture of the lens, the focal length of the lens, and the distance between you and the subject. Changing any of these three elements affords you almost complete control over the depth of field in a photograph.

When most of the picture is sharp the depth of field is said to be wide or long. When only part of the image is sharp the depth of field is said to be shallow or limited. Whether you go for maximum or shallow depth of field depends on the subject matter, and most importantly the creative impact you want the image to have.

LEFT **These tiny and delicate droplets of water, spotted on the petals of a garden plant, have been enhanced by the use of a shallow depth of focus. The lens, in macro-focus mode, has been set at its widest aperture of f/2.8.**

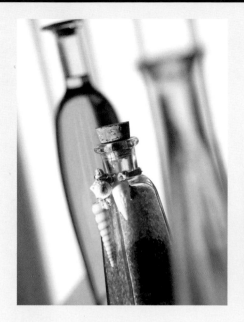 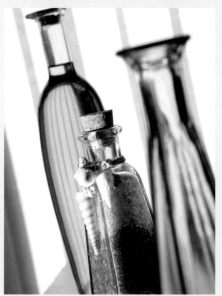 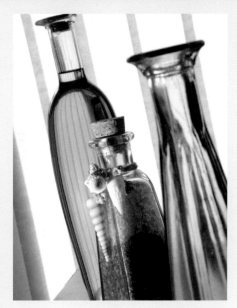

The aperture

There is a direct relationship between aperture size and depth of field – the smaller the aperture (the higher the 'f' number), the greater the depth of field.

To keep as much as possible of your picture sharp, you should set a small aperture – preferably f/16, or even f/22 if your lens 'stops down' that far.

Because a small aperture lets in less light, low-lighting conditions may dictate that you use a tripod or some other form of support otherwise the long shutter speed dictated by using a small aperture can cause camera-shake.

Alternatively you may want to force attention on just one element of the photograph, putting the rest out of focus. To do this, select a large aperture (low 'f' number). How large an aperture depends on the maximum aperture of the lens on your camera. On a 50mm standard fixed lens (35mm format) it will range from around f/1.7 to f/2, but on a standard zoom it will typically be only f/3.5 or f/4.5.

If you leave your camera set to 'auto', it will usually select an aperture of around f/8 to f/11, which will provide an image in which most of the picture is in focus. If you want to override this in order to set a shallow depth of field, take control of the aperture selection yourself and use the camera in either an aperture-priority (AP) or manual mode (M). This is one reason why buying a camera that has manual override is important if you want to explore your photographic creativity.

LEFT **This first image was shot at 1/60th of a second with an aperture of f/5.6 and a 55mm focal length. Because of the small aperture the resultant image has a depth of focus which only holds sharpness on the central bottle.**

CENTRE **The second image was shot at 1/8th of a second with an aperture of f/16. The result is a depth of focus which now begins to lose the sharpness of the three bottles. Note the consistent exposure that is maintained.**

RIGHT **The final image is a 1 second exposure with an aperture of f/32. The result is a depth of focus that has maximised the focus between all the objects. It has also confused the meaning of the shot. The best creative effect is seen at a wide aperture in the first shot.**

The focal length of the lens

Attach a wide-angle lens to your camera and you'll reap the benefit of extensive depth of field – in other words it's easy to keep everything in focus. This is why budget digital cameras opt for a focal length wider than a 50mm equivalent – it's hard to be out of focus! The wider the angle of view on a lens, the greater its depth of field. Choose instead a telephoto lens and the depth of field is immediately more limited. In other words, the longer the focal length of a lens, the more restricted the area of sharpness is going to be.

The camera-to-subject distance

This is quite an influential factor: the closer you get to the subject the more limited the depth of field becomes. In fact, when shooting close-up macro subjects it can extend to just a few millimetres in front of and behind the subject. This, however, can be useful to isolate the main subject area from a distracting background.

Creative Depth of Field

BELOW Auto-focus can be confused when the main subject is placed off centre. The camera ignores your subject and insists on focusing on the tree instead (see bottom). The solution is to centre your subject, lightly press the shutter release to lock auto-focus and then recompose the shot.

ABOVE This is how auto-focus may interpret a subject placed off centre unless corrected (see above). If deliberate, however, you can also use the technique to place emphasis on the tree bark by playing it off against the softly focused flower head.

RIGHT A 200mm telephoto image of kite surfers compresses perspective and maintains overall sharpness.

Applying this to practical digital camera work, therefore, here are four ways of using depth of field creatively:

Overall sharpness

To achieve overall sharpness, set a small aperture on the camera and use a wide-angle lens. This set up is ideal for landscapes, buildings and distant views.

If foreground interest is part of the shot, you may need to resort to a neat little trick that allows you to increase the depth of field. There is roughly twice as much depth of field behind the subject than in front of it. So, when photographing a landscape with foreground interest, simply focusing on infinity will waste potential depth of field. By focusing a little closer you'll extend the depth of field ensuring that the foreground is nicely in focus, while still making sure that the distant landscape also falls within the depth of field range behind the actual point of focus.

Sharp subject with background completely out of focus

There are occasions, in portraiture for instance, where attention is on the person rather than the location, when you may want the main subject to stand out from a potentially distracting background. Using a telephoto long focal length lens at its widest aperture will help achieve this by throwing the background out of focus. It does help to move the subject as far away as possible from the background – in domestic situations this is often impossible, but outside, against foliage or a building, it's usually easier. Be careful when focusing, however, because limited depth of field is unforgiving of focusing errors. A golden rule for portraits is to focus on the eyes for the best results.

Plants make fascinating subjects, but often have distracting backgrounds. Focusing close in on the flower head and softening the background is a common technique often used to isolate the subject.

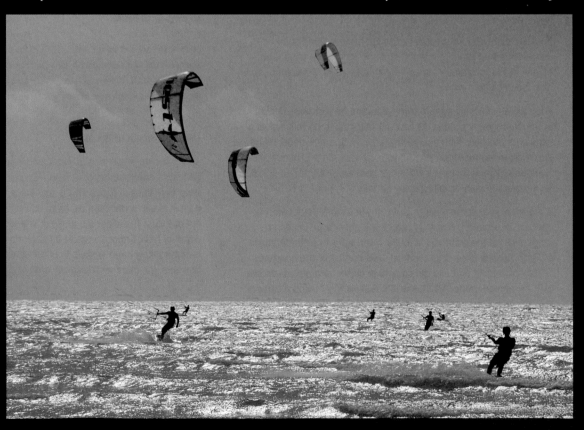

Sharp subject, background out of focus but evident

Sometimes throwing the background completely out of focus can be inappropriate. When shooting a holiday scene on the beach, a family eating in a café or flowers in a garden, for example, you may want to ensure that the background is sufficiently in focus to help contextualise the scene. In this case a standard to short telephoto lens – a 35mm equivalent of between 50mm and 135mm – with a middle range aperture of around f/8 will usually provide the right amount of focus.

Sharpness deliberately limited

Sometimes creativity demands that you may want to limit the depth of field to a very specific area. To create a flattering portrait, for example, you may want the eyes to be the only features of the face that are sharply in focus – not even the ears or the tip of the nose. Some prosumer cameras and all digital SLRs will have a depth-of-field scale around the lens mount to help calculate which elements will be in focus at certain apertures. You may even be fortunate enough to have a depth-of-field preview facility on your camera. This

usually takes the form of a button which, when depressed, shows you exactly what will and won't be in focus by manually closing the aperture to the f-stop it is set to.

Macro lens focusing

A successful macro (close-up) technique employed by botanical photographers is to greatly limit the depth of field for effect. The stamen of the flower for instance might be the only sharp part of the photograph, making the foreground and background petals really soft.

IN SUMMARY

- To maximise depth of field in order to hold as much of the image sharp as possible use a wide-angle lens, set a small aperture and stand back from your subject.
- To minimise depth of field with only a small section of the scene sharply focused use a telephoto lens, set a large aperture, and get closer to your subject.

BELOW LEFT Here, the point of focus is placed on the whiskery snout of the pig while the rest of the image is allowed to fall gently away. This provides recognisable background detail while at the same time ensuring that it is clear who is dominant in the composition.

BELOW Using a wide aperture of f/2.8 and fast shutter speed of $1/2000$th of a second it is possible to limit the depth of focus to the plane of the foreground leaf. Despite a wide aperture, by aligning squarely to the leaf it remains sharp across its width.

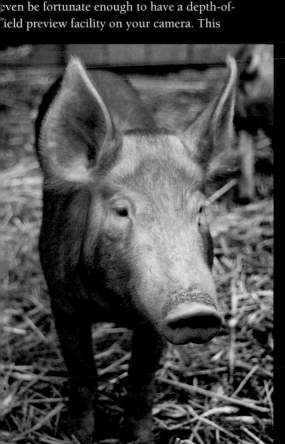

Taking Control

030-049

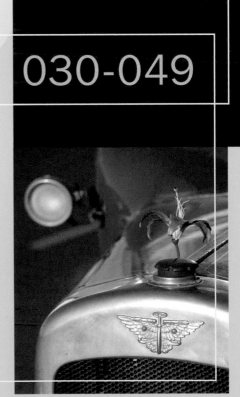

Getting the Correct Exposure

I t might seem an obvious statement, but the correct exposure for any scene is the exposure that delivers the picture you intended. If you are in control of the outcome you can decide on the camera settings for any photographic circumstance. In some scenes there may be a range of possible exposures that will work. Other scenes may have a greater range of light levels than the camera's sensor can cope with, so you'll need to choose the best exposure possible. Sometimes you have to deliberately give a technically incorrect exposure to get the artistic effect you want. In all these cases, the end justifies the means.

Metering

To help you achieve the correct exposure, all digital cameras have light-sensitive photocells that measure the light striking the sensor. The camera then calculates the exposure needed. However, more sophisticated digital cameras have a number of metering modes that ensure the camera still achieves the correct exposure even in complex lighting situations.

Learn through experimentation

Go out with your digital camera and try capturing the same subject in each of the three different exposure modes, then look at the differences for yourself. Consider a portrait where the sitter in front of a window is strongly backlit (i.e. bright light coming through the window). The matrix/evaluative setting will be influenced by the bright light, and will reduce the aperture size to account for this, thereby darkening the whole image and underexposing for the sitter's face. Using the spot meter setting instead, the camera can open up the aperture to expose for the face or body and allow the window backlight to flare behind the subject. This is a far more satisfactory solution, and will often result in an artistic lighting effect.

Remember, don't be afraid to push the boundaries. Digital photography, because of its 'film free' nature, is a form of photography that should encourage experimentation.

METERING SETTINGS

There are usually three main metering settings that control exposure:

Matrix/Evaluative metering – a clever system that performs calculations on readings from a number of small areas across the frame. It may be set to ignore points that are very bright or very dim in order not to be over-influenced by areas such as the sky in the picture.

Centre-weighted metering – this averages the reading for the entire scene, but gives greater emphasis to the centre of the picture. Some also read more of the bottom half of the image so as to avoid bright skies that might mislead the meter. Cameras that don't offer different metering modes will usually have centre-weighted metering.

Spot/Partial metering – assesses only a small area of the picture (usually the centre spot) in much the same way as if you held a cardboard tube to your eye in order to view the scene. This is an accurate method for pin-point exposure reading.

Getting to Know Your Camera

Having gained a basic understanding of your own digital camera and its controls, you can now confidently begin to discover the fun of picture making. Photography is very much about observing the world around you – noticing the small details in natural lighting effects, seeking viewpoints, and seeing colour. Setting aside all the technical issues for a moment, the great thing about digital photography is that it costs nothing at the point of capture – giving you the freedom to try out any creative ideas that may occur to you.

Experiment with the camera first on the automatic preset settings so that as you start to take pictures the idea of capturing a range of subjects in different situations begins to take effect. Soon you will realise that in fact there is rarely a situation in which 'there is nothing to photograph' – picture opportunities will start springing up all around you. Even the shadows created by your toothbrush on the bathroom wall become a fascinating play of shadow, shape and texture. Get the camera out and shoot it!

Power hungry

Apart from most digital SLRs and some prosumer models, digital cameras tend to react sluggishly when they are first switched on – and the delay takes a while to get used to. Oddly this limitation actually makes you more aware of the need to think ahead to the next shot in order to ready the camera in good time.

By their very nature, digital cameras use up a lot of power. The sensor, LCD screen, zoom and focus motors, not to mention the flash, all vie for the batteries' precious energy. To save power, an increasing number of digital cameras have a standby mode. In this mode the camera will automatically power down after a few minutes. To 'wake' the camera, all you need to do is press the shutter button. Without this feature you could be stalking about for hours at a time ready to take a picture only to discover that the camera has drained itself of power. It is strongly recommended that you carry spare (recharged) batteries at all times and get into the habit of putting exhausted batteries on charge as soon as you return home.

Trigger happy

If you are familiar with the layout of your camera controls and know where they are located, and the camera sits comfortably in your hands, then you are going to be happy taking photographs. If this description does not describe you, then take a few moments to learn again where the controls are located: click the main thumbwheel control knob around counting the positions up and down; with the camera at your side, try to become adept at first switching on and then holding up the camera primed and ready to take a photograph. Once you really know the physical layout of your camera you can concentrate fully on the subject.

Getting to grips

Whatever the model of camera you have chosen, some thought should be given to the way in which it is held and supported. A good technique will ensure that camera-shake is reduced to a minimum, and there are a few tricks you can employ to support the camera without having to use a tripod.

1 HORIZONTAL FRAMING WHILE STANDING
With feet slightly apart, support the base of the camera in the flat of one hand with your elbow against your chest. The thumb and index finger of the same hand can rotate the focus ring of the lens while the other hand controls the shutter release.

2 VERTICAL FRAMING WHILE STANDING
From the position described in step 1, rotate the body of the camera into a vertical plane. Again, by pushing the elbow of the arm supporting the camera against your chest some stability can be maintained.

3 A HUMAN TRIPOD
This is the firmest free-standing support you can achieve before resorting to a real tripod. The active support comes from the elbow resting on the knee and is helpful for modest slow exposures or support using a long focal length lens.

4 SUPPORT FROM SOLID OBJECTS
If you can find a wall to lean against this will help again on slow exposure times or with the use of a long focal length lens. Any method of support – stone wall, fence post, tabletop – can be enlisted. However, don't rely on these; it's much better to buy a tripod!

Seeing Through the Lens

Viewpoint

Have you ever considered that your choice of camera viewpoint can subtly influence the message in a photograph? In a portrait, for example, a high viewpoint dominates the sitter making them appear vulnerable, whereas a low viewpoint suggests a dominant character towering over the camera. A distant framed shot of a single figure suggests that you, as the photographer, were also distant (emotionally) from the subject.

Unusual or unexpected camera positions add drama – consider a view looking straight up into a vaulted cathedral roof, an aerial view from a tall building looking downwards or a dog's-eye view of the world. Always seek out the unusual and strive to be different. This can often mean breaking away from the normal eye-level viewpoints in search of this approach. If it has been raining look at the reflections of buildings in puddles in the street – can you find that creative view? In fact when you are taking these early experimental shots, say to yourself that for each shot taken you will try at least two other alternative viewpoints. This will help you to improve your creativity.

1 The distant figure is framed off centre and positioned so that your eye follows the diagonal lines of the bridge. A lonely, detached relationship is created between the subject and you, the viewer.

2 A low camera viewpoint and the assertive pose of the subject create a portrait in which the 'character' of the sitter is allowed to dominate the viewer.

A word of advice should be given at this point. Enthusiasm to find an unusual viewpoint can be mistaken by some people as the actions of a suspicious character. So always be cheerful and perhaps give a courteous wave, where necessary, to signal your innocent activity to strangers. Respect private property and seek permission if it is vital that you get the shot you want from a specific vantage point. I have found people to be very cooperative and helpful provided you explain what it is that you are up to.

1

2

3 Whatever subject you choose to photograph, consider up to three different ways of tackling the situation in order to challenge your creative thinking.

4 The high viewpoint and wide-angle lens dominates the dog making it look small, apologetic and rather 'guilty' to be sitting in the chair.

5 By doing no more than dropping to a low viewpoint and switching to a longer focal length lens the dog now appears to be defiant and unwilling to move from its comfortable position!

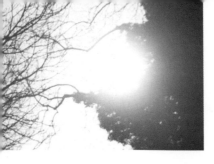

Daylight Photography

In photography the first golden rule is that there are no rules! If in the past you have followed advice that the sun should always be 'over your shoulder' when shooting, then you have been missing a lot of potential shots. To me, shooting directly into the light is the source of many dramatic images. Seeing the subject of the photograph backlit or edgelit by the sun, throwing strong forward shadows, can create a stunning image. The drama of natural light is ever present and as I outlined earlier, as a photographer you should note and study the subtle changes in light that occur during the course of a day. Having observed the effects, remember them – better still shoot examples – and add them to your armoury of lighting styles.

White balance

Depending on the light source, the colour of light can actually change – compare the warm reds of an evening sunset with the neutral white of midday. Even more apparent are the unattractive colour casts created by artificial light sources, such as tungsten or fluorescent light bulbs. While our eyes adjust so that light, whatever its source, appears neutral, a digital camera's sensor needs help to achieve the same effect. This help comes in the form of the camera's white balance settings –' usually a choice of 'auto', sunny, cloudy, tungsten,

fluorescent and flash. One of these settings will usually provide an acceptably neutral result. It's worth taking the time to consider the white balance setting, as an adjustment made at the time of capture will reduce the time spent in post-production on the computer – after all photography should be about 'being there' and less about spending hours chained to a computer.

Reflectors

Even in bright daylight, it may sometimes be necessary to use the camera's flash. For example, portraits taken outside in sunny conditions can sometimes show strong shadows on the subject's face. Using the flash as a 'fill in' can help soften the shadows. However, fill-in flash can sometimes create a harsh result and even introduce a colour cast into a scene. If this is the case, try using a reflector. The advantage of this method to light your subject is that you are pushing back into the shot the same quality of light that covers the whole of your scene. Colour casts are not an issue and a far more natural result is possible. A reflector could be a purpose-made collapsible photo reflector, which is white on one side and metallic silver on the reverse. Alternatively, try using a white bed sheet, a sheet of white paper or even a mirror. If you are inventive, anything that will reflect light is always worth trying.

BELOW **Daylight gently backlighting grasses at the end of a summer's day. Notice how crisply the light picks out the wispy feathers of the grass and also how the use of a shallow depth of focus helps to emphasise the main subject.**

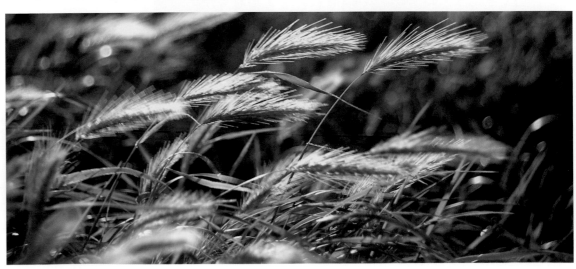

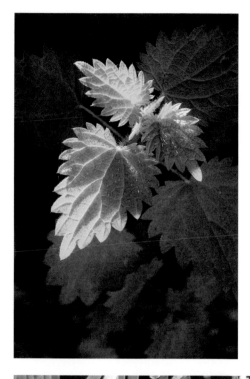

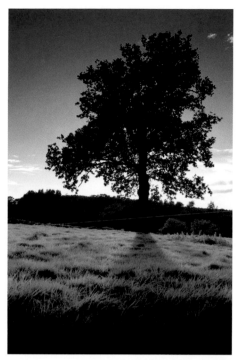

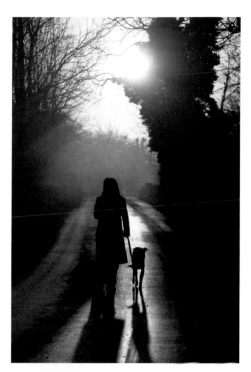

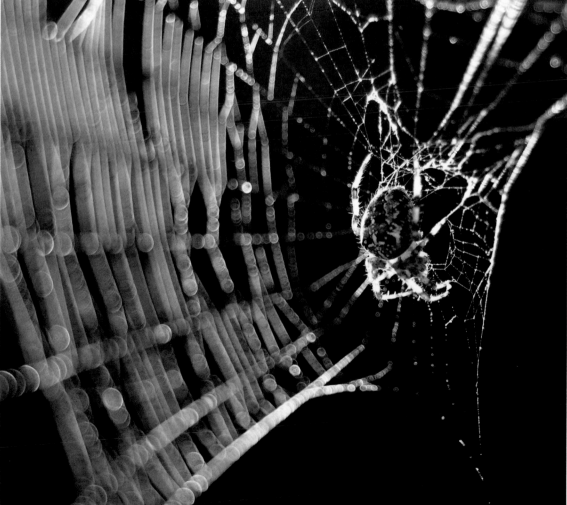

ABOVE LEFT **Simple and yet dramatic, the sun cuts sideways through the nettle leaf to reveal shape and texture. The dark background helps to emphasise the fresh green colour of the new leaf.**

ABOVE CENTRE **A lone tree is aligned directly in front of a setting sun. The resulting shadow races towards the camera forming a dark pathway to lead the eye into the picture.**

ABOVE RIGHT **An early morning mist diffuses a rising sun to spread soft yellowing light through the trees. An exposure based on the highlight tone results in a silhouette of the figure out walking her dog.**

LEFT **The spider is an ideal macro subject, captured very early in the morning as a low sun cuts across the fine web. The dark background adds drama to the strong backlit scene and again the narrow depth of field holds your attention.**

Using Flash

Most digital cameras feature a built-in flash unit to provide lighting in low-light situations. You should avoid using this as the only option available to light a scene because, used inappropriately, flash can create harsh images with hard-edged shadows. Try considering all the lighting options available in order to create a picture with more atmosphere. If light is low select a slower shutter speed and fill in with flash so that vital extra detail is retained. Some venues, however, such as concert halls or sports arenas are far too large for your flash to make any difference at all. In this case, it's best to override the flash, find a sturdy support to rest against or place your camera on and use a long, timed exposure with no flash – you'll be impressed with the result.

Red eye

Red eye is a self-inflicted problem that would disappear if the camera's flash was located away from the same axis as the lens. The problem is that light travelling out from the flash hits the blood vessels in the retina of the eye and is reflected back into the camera lens producing a characteristic red glow in the subject's eyes.

To counter this, some cameras have a feature called a red-eye reduction setting. With this setting on the camera sends out a short burst of flashes from the flash unit, which makes the subject's iris close slightly before the main flash is fired. But if the problem persists, don't panic, you can fix red eye quickly in most image-editing programs – some even do it automatically.

Bounce flash

Other issues can also arise when using flash. For example, a direct flash from the camera can often prove inadequate in its coverage of the scene particularly when used with a wide-angle lens. Alternatively, 'fall off' can often be detected when the flash is used on a close-up subject. Here the nearest object to the camera is registered as the correct exposure point and everything else then 'falls off' into darkness. If your camera has a Hot Shoe fitting, and you intend to do a lot of flash photography, it might be worth investing in an auxiliary flash unit, preferably one with a moveable head. With such a unit you can bounce the light off the ceiling, from where a soft and effective 'blanket' of light falls across the entire scene.

BELOW LEFT **Knowing whether to use fill-in flash or not can only be decided once you know how you want to portray the mood of your shot. In this first example fill in flash has been used and provides extra facial detail. The subject is mainly lit by window light.**

BELOW RIGHT **This shot has no flash fill-in lighting. I prefer this image; it has a stronger contrast as a result of the darker facial tone while it still skilfully retains detail. Just because your camera has flash you don't have to use it every time.**

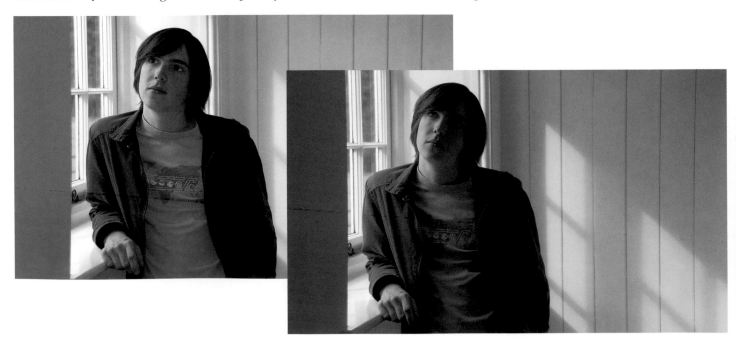

Balancing interiors

A common indoor lighting problem occurs when trying to photograph the interior of a room lit by daylight. The light outside the room is bright and the camera, in exposing for this, will create a darker interior as a result. Switching on the camera's auto flash will trigger a near full power discharge which illuminates the room but in the process also kills the natural lighting that spills into the room from the windows. The compromise is to set the camera to a speed and aperture manually that records the exterior detail while discharging the flash at a reduced power output. In the example shown here the flash was found to discharge too much light even at low power. So by placing a cotton handkerchief over the flash head the output was physically reduced by another stop and the perfect lighting balance was achieved.

TOP **The room is lit in this first image purely by the external daylight. As a result the windows are bright and the interior still too dark. It is undeniably moody as an image but has actually lost too much interior detail.**

ABOVE **It is worth noting that you can 'illuminate' an area with flash or you can 'light' an area with flash. The difference is subtle, but, in this case bashing out a full power flash output has certainly 'illuminated' the room and killed any atmosphere created by the natural light.**

LEFT **A balanced compromise achieved with the low-tech assistance of a white handkerchief. The camera exposure is set to record the window detail while the power of the flash is restrained by firing through a double layer of the folded cloth held out in front of the flash head.**

Composition

RIGHT The flowers inside the window and the flaking paintwork were framed in this shot as the main point of emphasis. The picture works to the rule of thirds so your eye will constantly return to the flaked paintwork and flowers.

BELOW LEFT The archway of a bridge spanning a river provided perfect framing for the power station's cooling towers. Once again the position has been determined by the rule of thirds. Lighting also plays a strong role in directing your eye.

BELOW RIGHT A fast grab shot spotted at a railway goods yard. The building was some distance away but by using a telephoto lens the arch filled the frame. The white bird would have been perfectly placed had it shuffled more to the left!

The secrets of a successful picture come down to some basic rules of composition together with effective lighting and an interesting choice of subject. Without wanting to labour the point there is no 'correct' way to take a picture.

If you ask two photographers to shoot the same scene each will create attractive images, but with totally different compositions. This is because we are all individuals and want to express our own feelings in different ways. Before taking a photograph, look at the scene in front of you and determine the main point of interest. By deciding which area is the most important to you, you can compose the picture to emphasise it. Studying commercial photographs created for advertising will show you the power of composition.

More good advice would be to try to keep your images uncluttered so that the subject of

your photo is the central focus of interest. If there are too many objects jostling for attention in the background, your message will certainly get lost. If it's not possible to frame your subject, try to isolate it in another way – for example, consider using depth-of-field control to keep the background out of focus. In terms of lighting, a well-lit subject will have more impact if placed against a dark background and vice versa. Creative use of colour can also help gain attention and may be used for extra emphasis.

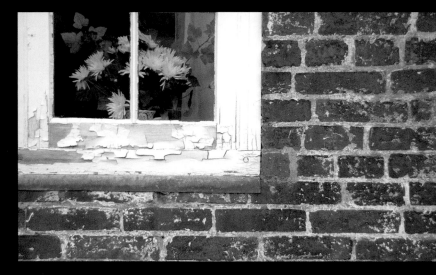

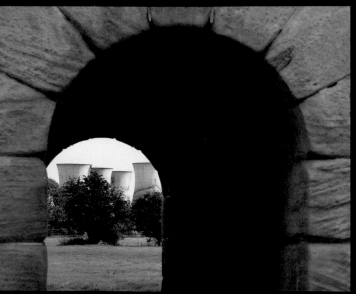

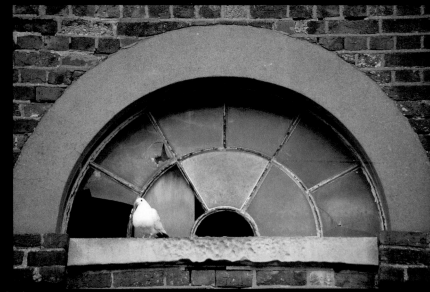

Positioning

Generally an informal balance is considered more aesthetically pleasing in a photograph than a symmetrical balance. Put simply, placing the main subject off centre and balancing the 'weight' with other objects will be more effective than placing the subject dead centre.

You can change a mundane picture dramatically by simply moving the camera up or down a little, or by stepping to one side. Decide on a camera viewpoint that is not just another run-of-the-mill stock view – one of the best ways to come up with an award-winning photograph is to find an 'unusual' point of view.

When your subject is active, such as an animal or person, it is best to leave space in front of the subject so it appears to be moving into, rather than out of, the photograph. Meanwhile, elements of a picture such as roads, rivers, and fences placed on the diagonal are generally seen as more dynamic than horizontals.

Rule of thirds

Last and by no means least, is a technique that really works called the 'rule of thirds'. This theory, which is widely taught on graphic design and photographic courses, is based on the theory that the eye will go naturally to a point about two-thirds up the page. Also, by visually dividing the image into thirds (either vertically, horizontally or both) you can achieve the informal or asymmetric balance mentioned earlier.

Although there are many ways a photograph can be composed effectively by basing it on the use of 'thirds', the most common example is the placement of the horizon line in landscape photography. If the area of interest is land or water, the horizon line will usually be two-thirds up from the bottom. If the sky is the area of emphasis, the horizon line will be one-third up from the bottom, leaving the sky to occupy the top two-thirds.

Remember, these are only guidelines; there are no specific hard and fast rules. While a beginner can achieve some quality results quickly with these guidelines, experienced photographers who know the rules rise to the challenge and find creative ways to break them – with excellent results.

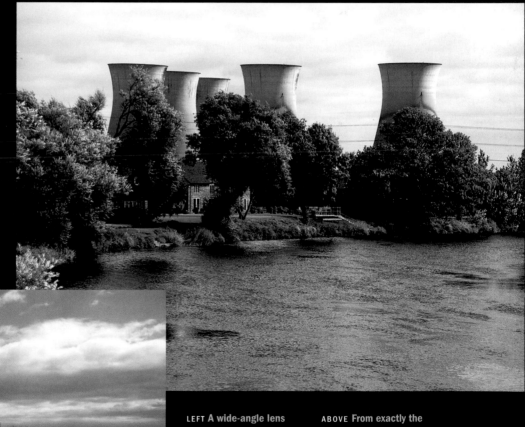

LEFT A wide-angle lens creates a wide vista across the river and promotes a country landscape (despite the cooling towers in the distance). The sky occupies half of the frame while the power station sits one third in

ABOVE From exactly the same viewpoint, but now through a telephoto lens, the composition can create mischief by inferring that the house is dwarfed by the power station. A rather neat demonstration proving that a photograph can influence your

Colour

BELOW **If you get up early, before sunrise, to take photographs, the light when recorded will often have a blue cast tinged with purple. The fishing basket in this shot was balanced with flash fill-in lighting.**

When photographing in colour there are a number of important decisions to make; where to position a coloured object against its background; whether to concentrate on bright, brilliant colours or muted, soft ones. Decisions such as these affect the mood and general impact of your pictures.

Colour photography used successfully is a compositional tool in its own right. Stop for a while before you make your next exposure and focus your attention only on the viewfinder image.

Now ask yourself the question, how do the colours in the scene relate to each other? Perhaps a change in camera position might bring one coloured object to a better position in relation to another. Or perhaps for a landscape shoot you should wait until sunset naturally turns the sky to a more brilliant hue. With digital there is no need to limit yourself to taking the first view of a scene that happens to come to your attention. There is no limit on film, so shoot first and keep shooting, and ask compositional questions later.

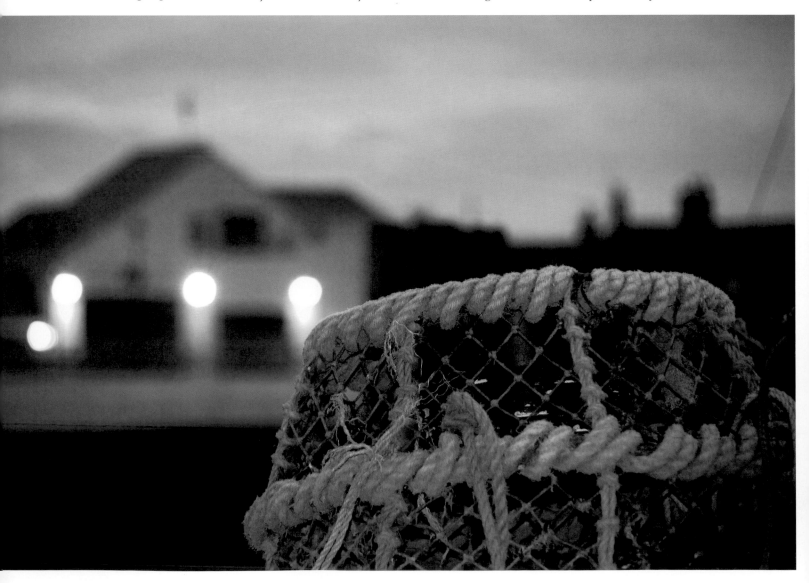

All in the mind

Colours often are said to create a 'psychological temperature'. In fact whole books have been written explaining the concepts of colour theory. Greens and blues, for example, are commonly associated with coolness, water, or ice, while reds and oranges on the other hand evoke fire and warmth. If you get to understand the effects of colour balance on your photography then you will become quite relaxed about predicting their effects on the scene. For instance, to make a room lit by standard lightbulbs look that little bit more cosy, shoot with a daylight White Balance setting – the warmer light temperature of the tungsten lamp will produce the 'cosy' warm reds that you are after. If you had set the camera to the Tungsten White Balance setting (as your camera manual instructs), the 'correct' White Balance setting would have neutralised any colour atmosphere in the shot. It again raises the point that once you know the rules you can start to test their limits and boundaries to create a better picture.

BELOW **A classic example of tungsten lighting mixed with daylight. The camera with manual White Balance set to daylight records correctly at the window but sees the table lamp in warm red hues. Result, a colourful cosy feeling created within the room.**

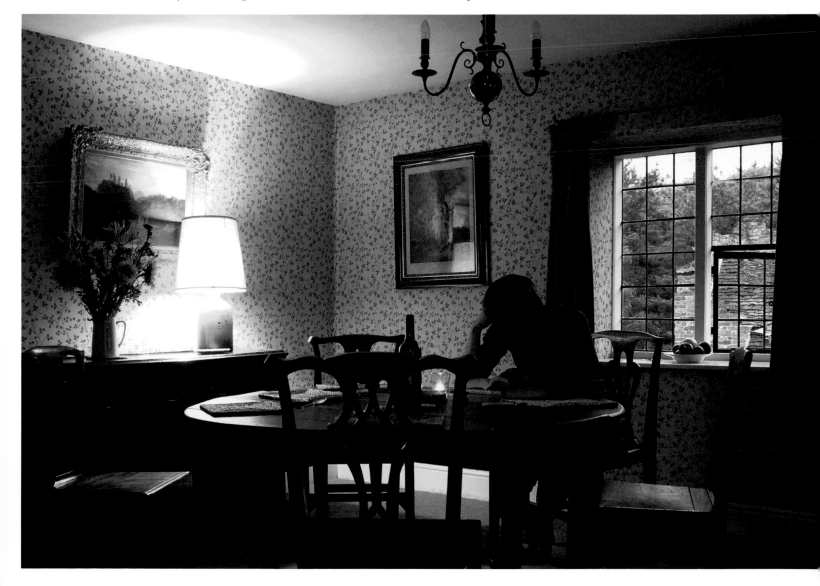

Colour

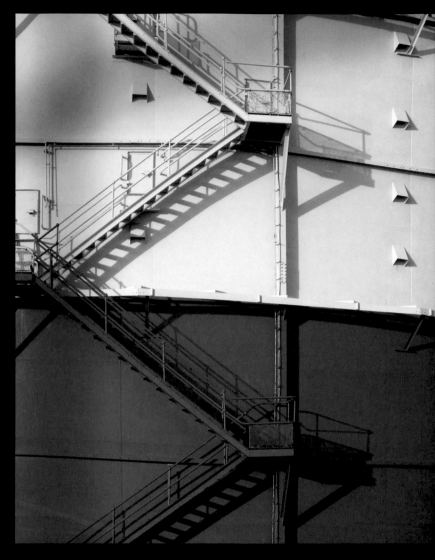

Turning up the heat

As a digital photographer you have the advantage of being able to artificially increase the colour depth and saturation of a picture using image-editing software – in fact you can pick out small areas of the picture or adjust the whole picture in its entirety. Restraint is still the order of the day, however. A common mistake people make is to increase colour saturation to garish levels. Overly saturated green grass and unreal deep blue skies in landscape photography is considered outlandish and will make your photograph look as though it is intended for display in an estate agent's window. It requires less application to produce an attention-grabbing image in bright primary colours because the colours do the talking. Want to test your skills? Why not take some photos featuring pastel shades and soft lighting.

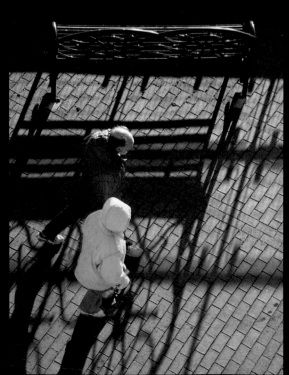

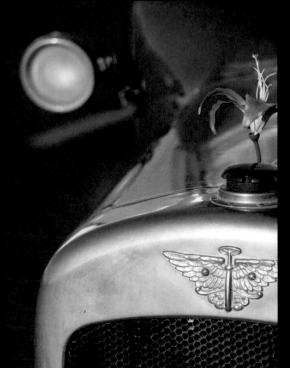

ABOVE The colours of the large gasometer create their own divisions within the frame and provide compositional interest within this tightly cropped image.

FAR LEFT Despite having framed up on the eye catching shadows on the floor, the arrival of two people in brightly coloured coats dictated the right moment to press the shutter.

LEFT A long lens chosen to compress perspective holds together the visual elements of a vintage vehicle and focuses attention on the flower in the radiator.

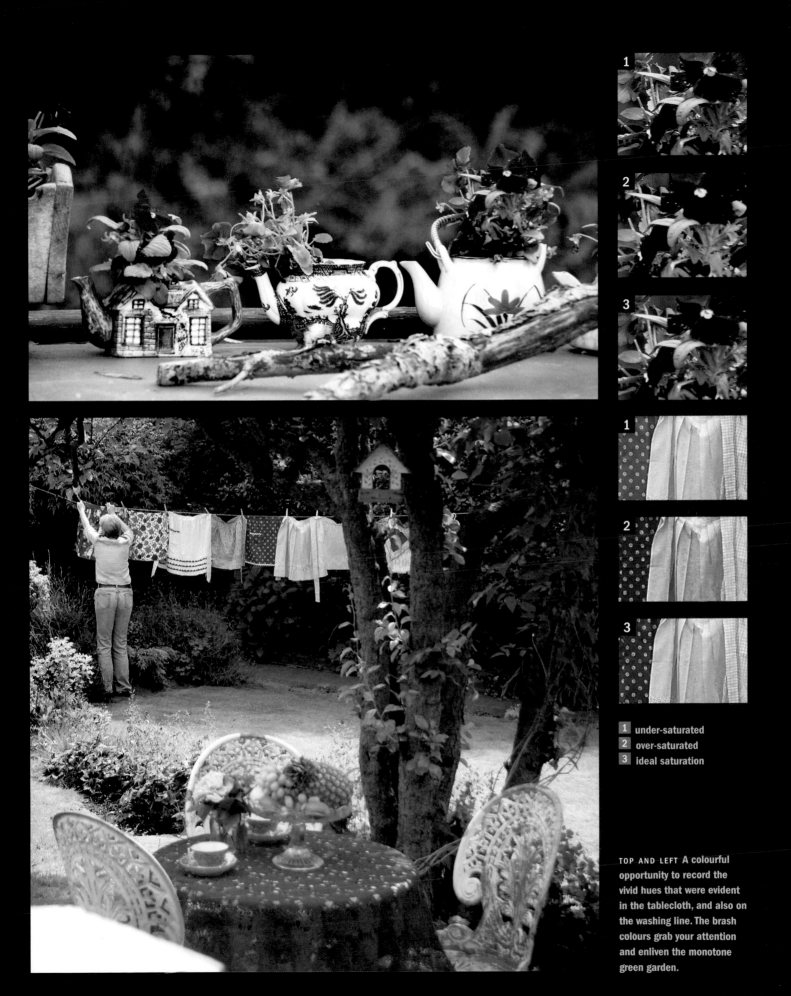

1 under-saturated
2 over-saturated
3 ideal saturation

TOP AND LEFT A colourful
opportunity to record the
vivid hues that were evident
in the tablecloth, and also on
the washing line. The brash
colours grab your attention
and enliven the monotone
green garden.

Colour

Going soft

RIGHT **The original autumnal-coloured image – vibrant leaves are strewn around the mossy tree base. Potentially, it is a picture that given adjustment can be presented in several guises.**

BELOW **The first option for the photograph is to desaturate the image colours to a monochrome appearance. Notice how the lack of colour now diverts the eye past the leaves to look instead at the lighter tree trunk.**

Pale and less saturated they may be, but pastel colours are as emotional in their own right as vibrant colours. Pastels bring a sense of peace and simplicity. These emotional cues are the very reason that interior designers place such importance on the choice of pastel colours to evoke harmony.

Skin tones fall into the pastel category, and in portraiture a selection of pastel-toned accessories will blend effortlessly into the picture. Here we have drifted into the world of 'high-key' lighting. In this style of photography the exposure readings are taken in the shadow area of a scene and so the resultant image overexposes the highlights. So effective is this technique that strong colours can be 'knocked' back to reproduce as pastel shades.

A collection of monotone-coloured objects selected to appear together can create a very stylish image. If this is then replicated in other shots of differing colour shades, a display can be mounted for graphic effect.

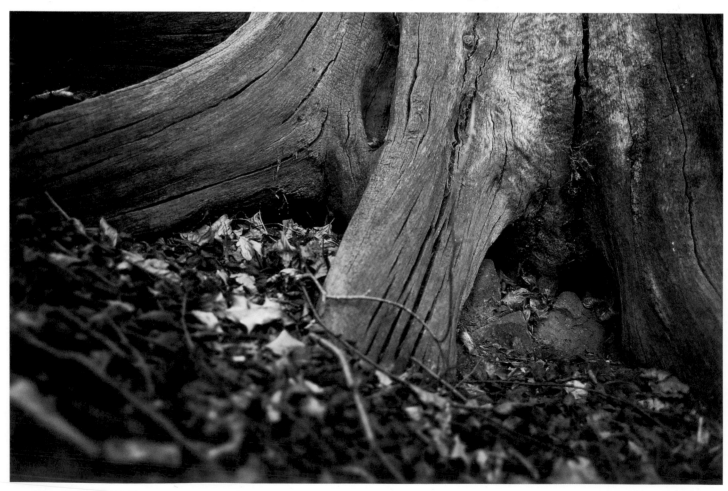

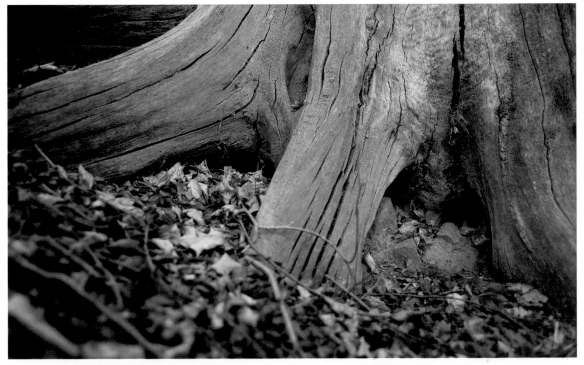

LEFT Using the adjust hue and saturation commands of image-editing software, it is possible to transform the picture to a darker bronze shade. This gives the image an antique tint which could be used to mimic the appearance of earlier photographic prints.

BELOW Another idea is to reduce the strength of colour saturation to the point at which it is just discernable. Muted colours are very atmospheric, given an appropriate subject, and also reflect images from the early days of colour photography.

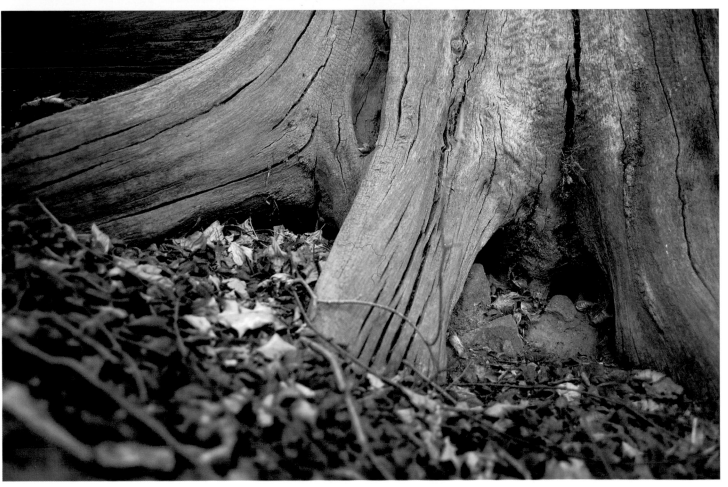

Colour

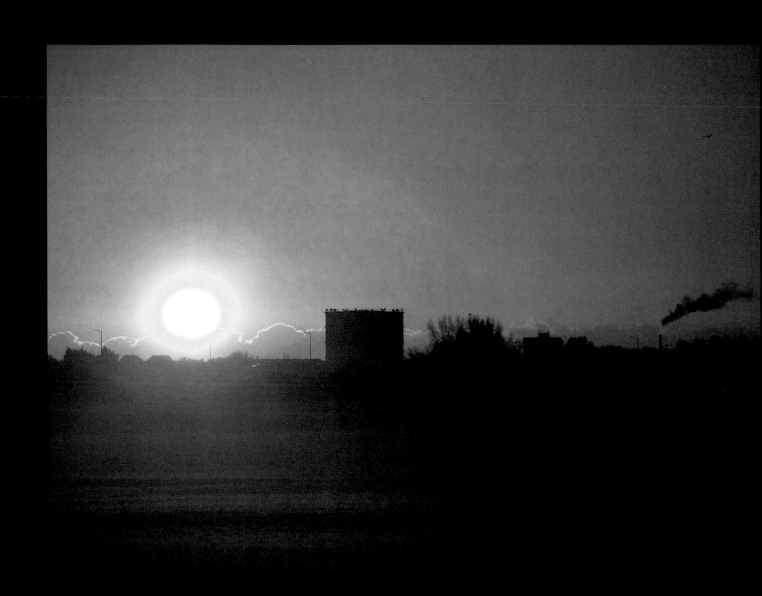

A blot on the landscape

Misty landscapes at sunrise are not only potentially stunning compositions in their own right, they can be made more striking by using careful exposure to achieve pastel tones. Of course as a digital photographer you could rework any of your images in the computer later – desaturating colour levels and manipulating the contrast and brightness levels. How much manipulation you undertake is down to your own personal philosophy on picture making, but a pure landscape image that survives with minimal tweaking and certainly no heavy retouching has to be thought of as being closer to the 'Holy Grail'. Of course in reality if, in attempting to shoot a pretty woodland scene, a bright orange plastic bag blows onto a barbed-wire fence across the other side of a field – just up from the abandoned burnt-out car – retouching does seem attractive!

A photo opportunity at sunrise is always worth getting up for. Whether landscape, town centre or industrial complex, they all look equally attractive against the sun's orange glow. SLR users please note: never look or focus through your lens if pointing directly up at the sun.

Digital black and white

Black and white images have always been, and continue to be, the favourite medium of most professional photographers. The absence of colour forces the photographer to deliver a clear photographic message through the use of lighting, composition and subject.

An increasing number of digital cameras feature a 'black and white' mode. Some work better than others. But even if your camera cannot shoot in black and white, don't worry. Many professional photographers who have switched to digital still think that better monochrome results are achieved shooting in colour and converting the image to monochrome later using image-editing software. Working this way also has the benefit of providing a colour image if one should be required.

Colour channels

A colour image is made up of three greyscale channels representing red, green and blue. To create a black and white image select one of the channels individually to see which carries the best tonal range. You do this by viewing the image on the computer screen and turning off each channel in turn to see where the best detail lies. No two pictures will produce the same results and as the colour contained in the original photographs change so does the choice of the file to keep or reject. When you are satisfied discard the other two channels, saving the remaining channel as a greyscale file – this will reduce your file size by two thirds. If necessary use the levels command to add contrast and inject some punch to the image.

This technique can make outdoor shots look fantastic, with blue skies taking on a really dark sinister feeling and allowing white clouds to stand out. Taking the idea further you could mimic the dark sky tones found in some black and white infrared images. If you are getting excited by the prospect of creative image making complete a few self-imposed exercises in black and white to test your skills. If nothing else, the experience of black and white image conversion should be attempted – the results will give you immense satisfaction.

RIGHT The original colour image file has both dramatic viewpoint and good lighting. Can it be pushed creatively any further? Yes, as a strong black and white image – see below!

BELOW By using the colour channels adjustment (see main text) it is possible to add tonal 'punch' to an image. Black and white images are a preferred form of expression favoured by many professional photographers.

Digital Image Editing

050-079

Getting Started

Having carefully composed and captured your images, what's the next step? An old anecdote within the photographic profession was that the average amateur photographer was a person who always had a Christmas tree at both ends of the film. A slight exaggeration but you get the message – it's easy to leave images in the camera and never quite get around to printing them.

With digital photography there are many options available to you when outputting your files. This section takes you through the various routes, starting with computer hardware, the various software requirements, and then into image editing.

What's in a name?

The digital image file can be saved in a range of formats depending on the specifications and capabilities of your camera. It could be the common 'Jpeg' (pronounced jay-peg) compressed file, the uncompressed 'Tiff' file or the native 'RAW' camera format.

The Jpeg file tends to be the most common format, with just about all cameras, from entry-level to professional, capable of shooting in this format. Embedded in Jpeg files are all the conversions and preferences set by the camera at the time of shooting. With most cameras, you can choose between 'low', 'medium' and 'fine' (although the terms used to describe these settings vary from camera to camera, with many referring to 'small',

'normal' or 'large'). The settings control how much the camera compresses a Jpeg image file before it is written to the storage card. Unless you're specifically shooting images to put on the Web, avoid the lower/smaller settings if you can and save at the highest/largest quality setting to maintain image quality.

The Tiff file format is a larger file; all the camera's settings are embedded in Tiff files but in an uncompressed form. The large file size limits the number of shots that can be taken before the storage card becomes full. Obviously you can choose the final image size and resolution before shooting to control the number of shots available, but large files equate to higher quality, and if you shoot at too low a resolution just to cram in more shots don't be upset when you try to enlarge them! The more an image is compressed by the camera's software, the more degraded the image.

If your camera supports the RAW format, this is the setting to choose when you demand the best image possible. RAW remembers your preferential settings from the camera but requires you to 'post-process' the file on a computer in order to bring out the best quality possible. A RAW file is unlikely to yield good-quality images if sent directly from a camera to a printer. In some cameras both RAW and Jpeg files can be captured at the same time and each respective quality setting determined separately. A RAW file can be thought of as an 'unprocessed digital negative'.

TOP **This image of a church tower is cropped from a section at the top of a full frame 38Mb digital image.**

1 **An enlargement from a section of the above image as a Jpeg file when saved at the high-quality setting. The image quality has survived compression and is good.**

2 **An enlargement of the image as a Jpeg file when compressed at a medium quality setting. The lower quality begins to show at this setting.**

3 **An enlargement of the image as a Jpeg file when saved at a low quality setting. Notice the poor quality and clustering of 'noise'.**

FILE FORMATS IN BRIEF

File type	Characteristics	Comment
Jpeg	Compressed file format	Reduced quality at high compression settings
Tiff	Uncompressed 'processed' image	Creates large file sizes
RAW	Maximum image information	Medium file size processed via external software.

What Can Digital Do For Me?

In the past, when shooting film, unless you owned your own darkroom and processing equipment, the possibility of improving and manipulating an image lay in the hands of the photo laboratory. As a result colour correction, cropping, retouching and so on had to be undertaken by a lab technician on your behalf. The way round this was to compose and correct in the camera (using colour balancing filters and effects filters over the lens) and aim to get it right on the negative or transparency. For the dedicated photographer this was all part of the process that led to the creation of the final image. For the majority of people, who were simply shooting pictures as records of holidays and specific celebrations to show family and friends, then it was simply a case of hoping the photo-processing machine would provide some happy memories. The usual hope was that there might be a good shot somewhere to be seen providing that 'it came out alright'.

We're all technicians now

Along came digital photography, into a world where the demand for a fast delivery of images (faster than film processing) was prompted by a change in the way we live and work. Email, desktop publishing, Internet websites, multimedia presentations, newsletters, online auctions, property adverts and Web forums are just a few examples of where our images can now be used. Suddenly we are involved in both taking and then 'processing' our own images in order to make effective use of them. While there are obvious reasons why the skills of professional photographic services will always be necessary, the 'self-sufficient' approach created by digital imaging has firmly taken hold.

Going, going, gone!

It may come as no surprise to learn that some people reading this book are doing so because they have bought a digital camera simply to photograph items to sell on an online auction site. Here the requirement is not to be creative when photographing an object but simply to supply a clean, crisp, well-lit and in-focus shot of the object for sale. Nobody will want to buy from a site that shows a dark, unclear image poorly presented on an inappropriate background. Take a leaf from the images seen in catalogues – study how they have been lit; use bounce flash to get soft, sympathetic, even lighting; only include the object in the picture; shoot against an even-toned background and crop close so that the picture area is used efficiently – after all you are using photography to sell for you. Having captured the image you may need to correct the files on a computer to get the clarity and colour right for Web reproduction. How you can achieve this is covered within this chapter.

BELOW Spending more time at your computer is the trade-off for being able to process and manipulate your own images. With so many applications demanding digital images it is important that you are able to provide correctly sized file types and meet image specifications.

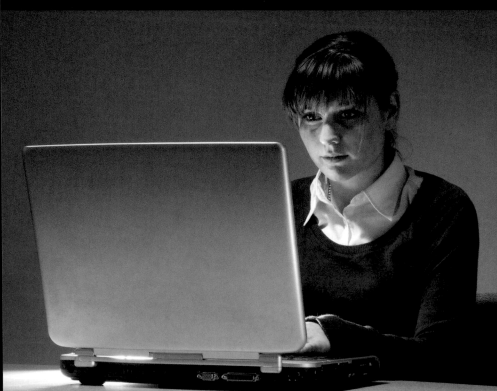

1 CLOSE CROPPING
Sometimes close cropping of an image retains the subject detail while getting in much closer to the point of interest.

2 GOOD LIGHTING
If you choose to shoot in poor lighting conditions you can expect poor results. This specifically selected high viewpoint takes advantage of the metallic surfaces reflecting the bright sky.

3 APPROPRIATE BACKGROUND
For online auction photography a plain background (not necessarily white) provides a clean presentation of your item for sale. It looks a whole lot better than framing up on the kitchen table complete with kettle and dustbin in the background!

4 FOCUS
An obvious requirement, but hard to achieve if you have only got a fixed focus compact whose closest focusing distance is 1.5m. You sometimes need to get in close to an object, so ensure that your camera meets your needs.

5 GROUPING
It is easy to display a single product but harder to group without overlapping several items. The need to show clearly what you are selling will probably override creative presentation.

6 SCALE
Have you helped to indicate the size of your subject in any way? A hand is a useful size indicator but a coin or ruler is aesthetically too obvious and over technical.

Computer Hardware

The first thing to say about computer hardware is that there is no right or wrong computer system for digital imaging. Whether you choose a Windows-based PC or a Macintosh computer is of little consequence. Both systems successfully handle digital image files, run the more common image-editing programs, are compatible with mainstream digital cameras, and can prepare images for the Web or for printing. Your decision will probably be influenced by budget or past experience of a particular operating system. Computer processing power, just like digital camera technology, is advancing at a terrific pace – the certainty is that most modern computers are going to be more than capable of coping with the demands of digital imaging.

The monitor

In many ways the monitor is the most important component in the digital-imaging workstation – the display is the means by which you evaluate the appearance of your image. Choose a monitor that will allow you to control the three colour channels (red, green and blue) individually and adjust white point settings. Also buy a flat screen if you can because these provide a more accurate and less distorted image at the corners. A large screen will be helpful when working on an image for fine detailed retouching, although an ideal size of 17–19ins is preferable in order to display sharp images. LCD screens take up less room on the desk and improving technology has meant that they display colours in a more uniform way, making recent models much more viable for image editing. A definite advantage with LCD screens is that they do not suffer from screen flicker unlike CRT screens and are therefore easier on your eyes during a long session.

Colour control

Colour reproduction requires careful management in a digital workflow because every device from scanner to camera, monitor to printer presents colour in different ways. Often they employ different methods of specifying colours (i.e., RGB for monitors, CMYK for printers). Each also has its own gamut (which is the range of colours a device is capable of displaying) – often referred to as a colour space. An RGB colour value of Red:225; Green:50; Blue:50, for instance, is red, but without colour management it will almost certainly be a different shade of red when printed on two different printers. Furthermore, without colour management the same colour values will also almost certainly display as a different shade of red on two different monitors, too.

Optimising your monitor

Make sure that your monitor is adjusted for the way you usually use it, that is with the same level of ambient light as you typically have when editing photos. Eliminate any harsh glare by pulling down window blinds or angling the monitor away from the light.

To optimise your monitor it is necessary to set the gamma level. When you adjust monitor gamma, you change the tonal value of midtones on your display. Displays for Macintosh computers operate at a gamma of 1.8, while older PC monitors function at a gamma of 2.5. There is movement to standardise monitor display parameters so that everyone sees the same colours when viewing pages on the Web. The standard chosen is the sRGB colour model that specifies a gamma of 2.2. If you own a copy of Adobe Photoshop you can use the Adobe Gamma utility to set your PC monitor. Mac users have a separate Gamma Control panel for monitors within the operating system.

Next, set the monitor's contrast and brightness levels to achieve their optimum points. The goal is to make RGB value (0,0,0) correspond to

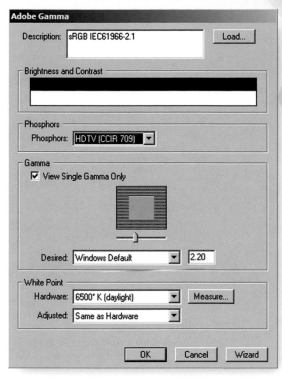

0% brightness, or black point. When you adjust contrast you are adjusting the video signal amplification. The goal is to make RGB value (255,255,255) correspond to 100% brightness, or white point. Most monitors have buttons or dials on the front of the case for these adjustments – check your monitor user guide if you're in any doubt.

To confirm the colour relationships of your monitor to your printer, take an image file and print it out at a high-quality setting. Now open the image file in your image-editing program and hold the picture up to the monitor so you can compare the two. From here it's a matter of adjusting the colour levels until the printed and on-screen images appear the same. It takes a good eye to match the red, green, and blue levels to the test image. If you have problems there are many useful websites that offer tips on fine-tuning your monitor's colour.

The computer

Images quickly consume a computer's memory and when image-editing programs are in use even more demand is made of the computer. When carrying out a complex manipulation sequence the computer has to cope with duplicates of large image files (often in layered form), maintain a history record to undo adjustments and operate filters and tools that demand heavy processor

calculations. As a consequence you should fit as much RAM into a computer workstation as you can afford – this is possibly more important than selecting a fast processor.

The second consideration is the size of the computer's hard disk for image storage. Quite simply get as big a disk as you can afford, it will fill up very quickly with your images. Ideally choose an ATA Drive of a speed above 7,200rpm for fast response and performance. Additional external drives linked via a Firewire or USB 2.00 connection can assist growing storage needs. To prevent the disks from eventually choking up with older files it is important periodically to archive images onto DVD or CD-ROM, and so a CD/DVD writer should also be fitted into the computer.

SITTING COMFORTABLY?

Digital photography manipulation at the computer will undoubtedly consume part of your spare time. It will take much longer to critically adjust your images than you may at first realise and as a result hours fly by and late night sessions will ensue. If this happens to you at least make sure that your workstation is correctly set for monitor height and that you have a comfortable chair in which to sit.

LEFT **For PC users with Photoshop Elements, running Adobe Gamma (which comes with the software) will help you to calibrate your monitor. A calibrated monitor will help you to achieve accurately coloured prints.**

Image-editing Software

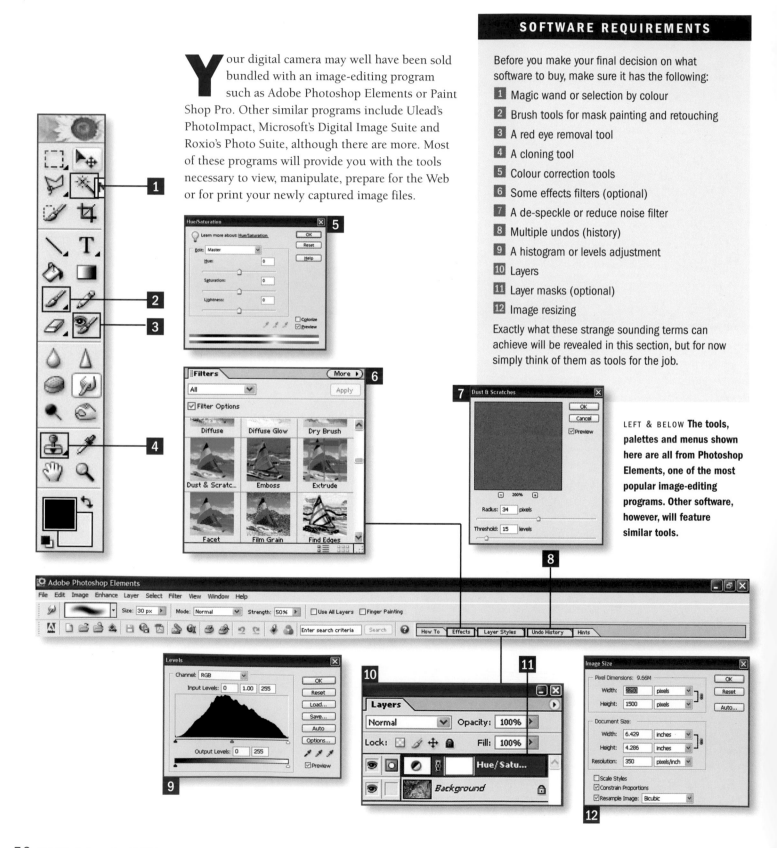

Your digital camera may well have been sold bundled with an image-editing program such as Adobe Photoshop Elements or Paint Shop Pro. Other similar programs include Ulead's PhotoImpact, Microsoft's Digital Image Suite and Roxio's Photo Suite, although there are more. Most of these programs will provide you with the tools necessary to view, manipulate, prepare for the Web or for print your newly captured image files.

SOFTWARE REQUIREMENTS

Before you make your final decision on what software to buy, make sure it has the following:

1 Magic wand or selection by colour

2 Brush tools for mask painting and retouching

3 A red eye removal tool

4 A cloning tool

5 Colour correction tools

6 Some effects filters (optional)

7 A de-speckle or reduce noise filter

8 Multiple undos (history)

9 A histogram or levels adjustment

10 Layers

11 Layer masks (optional)

12 Image resizing

Exactly what these strange sounding terms can achieve will be revealed in this section, but for now simply think of them as tools for the job.

LEFT & BELOW **The tools, palettes and menus shown here are all from Photoshop Elements, one of the most popular image-editing programs. Other software, however, will feature similar tools.**

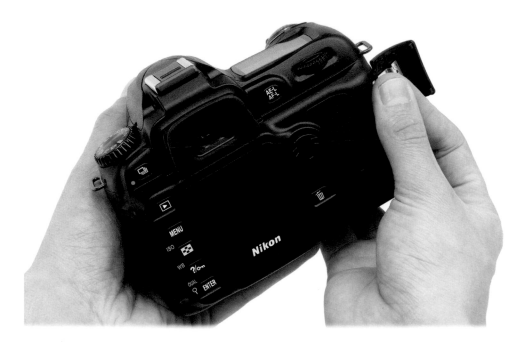

Other software

Your camera manufacturer will also have supplied a disc containing system drivers and files that will allow your image-editing program to recognise your camera and to access images downloaded from it. There are usually other simple system programs that come with your operating system that can open and view digital files. These are great for sorting and viewing files but limited in terms of image editing. It is also possible to get basic slide show software that will replay your jpeg files as a sequence of dissolving images on the computer screen. This is a great way to sit back first and view the camera files before you begin to edit them. Treat it like the lightbox that, historically, was used to view transparencies – a way to look at, organise and discard unwanted images.

Downloading your photos

If the captured images are still in the camera you will first need to transfer them onto the computer's hard drive. First, connect the camera to the computer either using the USB connecting cable, the Firewire cable, the Wireless network link or the Bluetooth connection, as appropriate. Alternatively, you may find it easier to buy a card reader which can remain connected to the computer. All you have to do is take the card from the camera and put it into the card reader. Next, create a folder on your hard drive in which to copy across all of your files from the camera. Check that all images have copied across, open up a few to confirm that the images have not become corrupt during the transfer and then only when you are satisfied that all the images have transferred safely, can you reformat the memory card ready to use again.

BELOW LEFT **Your camera may be configured to take more than one type of memory card or microdrive. By filling all the available slots you will increase your shooting capacity.**

BELOW **This screen shot is of a typical raw image viewer that displays the captured images as thumbnails and from which it is possible to select preferences of colour balance, exposure, and so on prior to saving the images as Tiff files.**

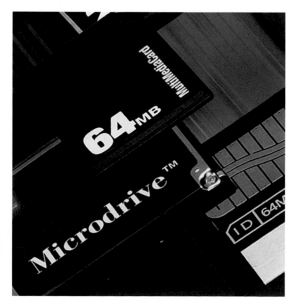

Basic Image Adjustment

BELOW LEFT **The original image with its histogram, a graphic representation of the image's tones, ranging from pure black (0) at the left, to pure white (225) on the right.**

BELOW RIGHT **The image contrast can be changed subtly by manually sliding the adjustment triangles in from either side. In this example only the shadow slider (left) has been brought in to the centre very slightly to increase the contrast.**

Open up your image-editing program and then, via the file browser or equivalent, select an image file, double click it and open it into the application. The file is now ready to be worked on. There are several options open to you to enhance an image – for example by changing the 'Levels' setting you can control image brightness and contrast as well as basic colour balance.

You can see below the difference between the original file and the adjusted file and the improved balance that has resulted. This is the most basic improvement to be made, the next can be quite subtle and modifies the colour balance. As always the decision to make any adjustments is one of personal subjective choice. You were there taking the picture, making decisions about cropping and composition so, rightly, the final outcome of the image rests with you.

ADJUSTING BRIGHTNESS LEVELS

If you are using Photoshop Elements the steps would be as follows:

- Go to Image > Adjustments > Levels (or use the keyboard shortcut Ctrl/Cmd-L).
- Study the histogram (see below) and see where the tonal range is lying.
- Slide the shadow and highlight points across to meet the start and end points of the histogram.
- Take the mid-tone slider bar and move it either left or right to adjust the brightness.
- Accept the changes by clicking 'OK'.

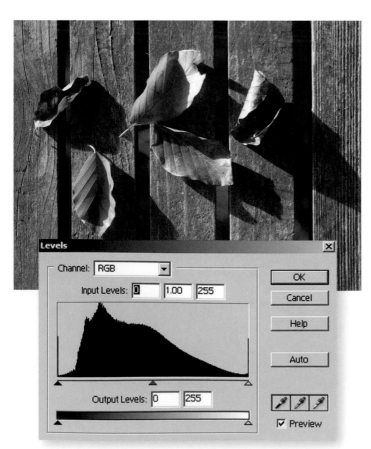

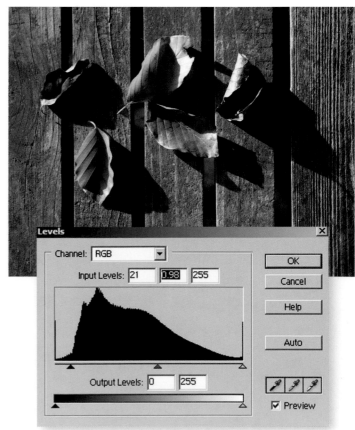

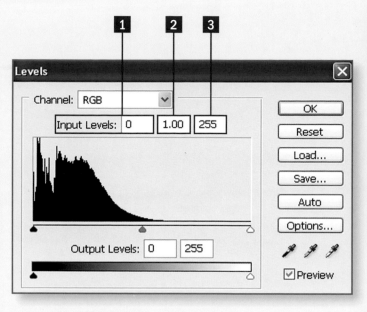

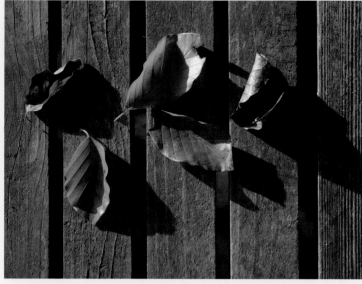

THE UNDEREXPOSED IMAGE

1 The optimum start point for black is 0. The slider controls allow you to compensate for subjects that are out of range. In this underexposed example the curve is pushed far to the left and lacks any information from midpoint to the highlight region.

2 The midpoint value slider represents grey tone (128) and by adjusting the slider within the actual image curve you determine the mid-tone information without adversely changing highlight and shadow regions.

3 The white point's highest value of 255 is the optimum to efficiently distribute the full tonal range. Again the sliders allow you to 'stretch' an incorrectly exposed image so that its values will forcibly conform to the correct exposure range.

READING HISTOGRAMS

A histogram provides a diagrammatic interpretation of an image's tonal range – 0 (the left end) represents pure black and 255 (the right end) represents pure white. The shape of the histogram is determined by the number of pixels in any given tonal value. If there is a large concentration in the left region of the histogram, it indicates that the image has lots of information in the shadow areas (and may be underexposed), whereas a large concentration in the right of the histogram indicates more information in the highlights (and may indicate overexposure). Learning to read and understand histograms when taking photographs is an excellent way of gauging whether or not your image is correctly exposed – particularly in bright sunshine, when looking at a small preview on the camera's LCD screen, to assess an image's exposure can often be very difficult and may lead to a misreading of the exposure.

THE OVEREXPOSED IMAGE

4 The default start point for black is 0. You can compensate for subjects that are out of range so they adhere to this 0 start point by using the sliders. In this overexposed example the curve is pushed far to the right and lacks information in the midpoint to shadow region. The output box displays your final intended black point.

5 This box displays the white point parameters which by default are set to 255.

6 The slider bar represents the tonal range of the final output. The white point's highest value of 255 is the optimum target to spread the tonal range efficiently. Again you can 'stretch' an incorrectly exposed image so that its tonal values will conform to the optimum exposure range.

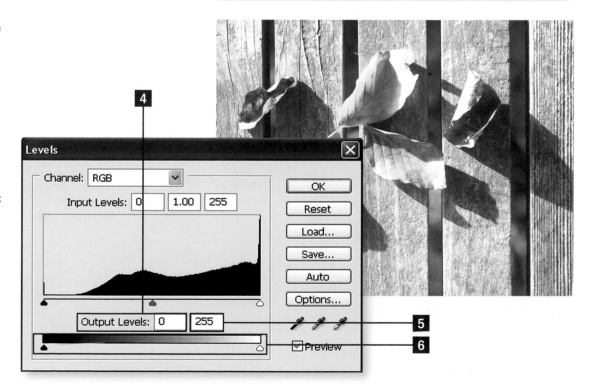

Colour Adjustment

You might think, having set the white balance correctly when taking a photograph that, when viewed on a monitor, the image will appear to have accurate-looking colours and not, for example, appear too red, blue or green. For certain brightly coloured scenes an adjustment may seem unnecessary because you may like the saturated tones and the upbeat image before you. This is the subjective nature of digital photography and in particular a colour cast can be invisible to the eyes of some people and yet disturbingly obvious to others. When subtle pastel colours or skin tones appear in the picture, the evidence of incorrect coloration becomes more apparent.

Before you make colour adjustments to your digital image file you should be confident that the monitor is displaying colours accurately. If you're in any doubt about this your image-editing software or main operating system may provide a help feature that shows you how to calibrate the monitor. Alternatively, if you have colour printer, compare a colour print to the image on screen and make any necessary adjustments. Second, check that the room in which you make the adjustment is not so brightly lit that it 'flattens' the contrast of the screen. Equally, by sitting in a darkened room, the relative brightness of the screen may make you over-compensate the adjustment and make the image file needlessly dark. All these external influences affect the success of your image and we haven't even mentioned the software yet!

BELOW RIGHT **What a difference a day makes, that is, in terms of colour temperature. At sunset a yellowing sun and long shadows clip the earth producing dramatic lighting. Warning: don't hit auto colour correction if you aim to retain this mood!**

BELOW **If you get up late each day you'll never fully appreciate the beauty of a sunrise. No two mornings are ever the same and, if you have researched a good location, the possibility of a dramatic picture is always present. Notice the blue-tinted shadows in this particular sunrise shot.**

Using Colour Variations

Open up your image in the editing software; go to Enhance > Adjust Colour finally choose Colour Variations. This presents you with a control panel of alternative colour suggestions for your image. The choices adjust the individual colour bias of the image using the red, green, blue channels. This method is very easy to understand since the effect of any change is made immediately visible to you via the small thumbnail images. The best way to learn how the tool works is to try it on a few extreme examples so that by observation you will see the results of over- and under-correction. Take for instance the pictures shown here of the terrace of pastel painted houses. By influencing the colour balance for one house you will see how the other colours can be 'drained' from the walls or given more strength and saturation. The differences can be subtle, but with perseverance a few moments spent correcting and fine-tuning the colour will make all the difference. So often in digital photography you will only discover the real effects and influences of photo-editing software if you take an image and try out the tools and effects on it yourself.

1 Changes on the terrace of houses: notice firstly that an increase in the blue slider produces a noticeable blue cast to the neutral grey roof and removes the yellow content of the green coloured house.

2 Now, by increasing the yellow slider the blue house is much weaker in colour, the green house is strengthened and the grey roof is tinged with yellow.

3 Increasing the green input boosts the green house saturation, sends the blue house turquoise and the roof a greenish shade. So you can see that a single colour cast adjustment has a 'knock on' effect for the whole image.

BELOW The original image of the subtly coloured terrace of houses should be compared with the adjusted images to the side. Notice how the single colour cast influences all aspects of the image.

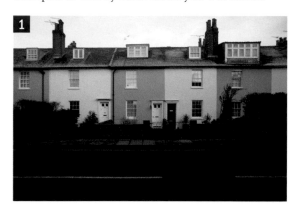

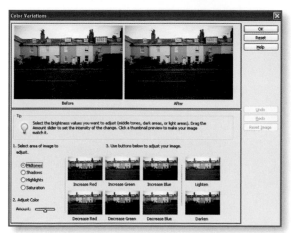

Cropping

An effective method of controlling the composition of a photograph is by using the Crop tool. This tool allows you to 'tighten' the visual appearance of your work so that you tell the viewer 'this is how I want you to see my work'. Your image could be positioned within a print area using the guide lines covered in composition and the rule of thirds. The new proportions can then be applied by extending the cropping area around the print, and then adjusting separately the width and height guides. Once satisfied with the proportions you simply hit the Enter button and the new cropping co-ordinates are applied. Think of the Crop tool as editing the image to remove the weak and irrelevant areas of a photograph.

Keeping in shape
By the very act of cropping you will be throwing away image information and producing a smaller file as a result, which will result in a smaller print. This is not always desirable. So when the Crop tool is selected in most image-editing programs it allows you to specify the pixels per inch (ppi) and crop size preference for your output in the Options Bar. Instead of getting smaller you could now ask the cropping tool to enlarge the image to a size larger than the original. However, this will involve some interpolation (by which the program 'guesses' at the new information to add based on neighbouring pixels), which can sometimes degrade the image. So enlarge images with care.

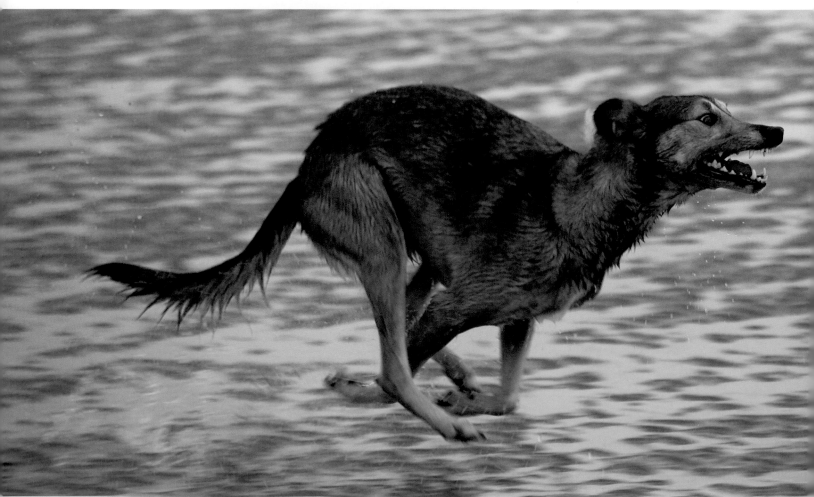

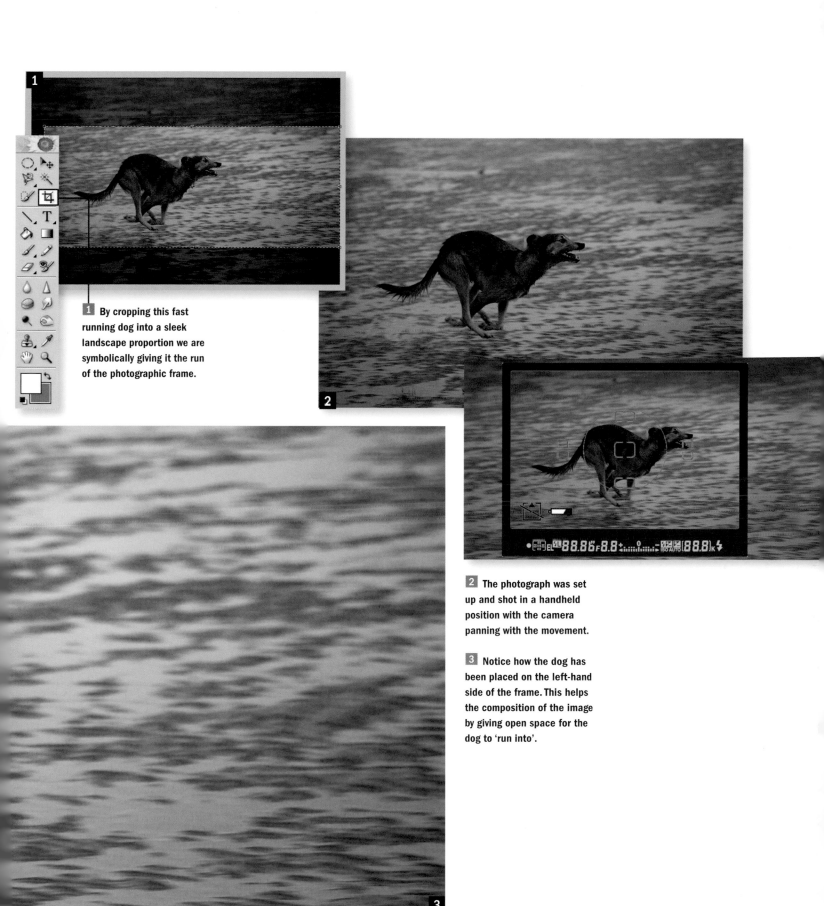

1 By cropping this fast running dog into a sleek landscape proportion we are symbolically giving it the run of the photographic frame.

2 The photograph was set up and shot in a handheld position with the camera panning with the movement.

3 Notice how the dog has been placed on the left-hand side of the frame. This helps the composition of the image by giving open space for the dog to 'run into'.

Digital Image Dimensions

IN DIGITAL IMAGING THERE ARE FOUR BASIC MEASURES OF IMAGE SIZE
Pixel count – shown as width x height in pixels
Physical size – given as width x height in units (e.g. inches, mm, cm etc.)
Resolution – shown as pixels per inch (ppi) (e.g. screen resolution of 72 ppi)
File size – the digital size of the image (measured in kilobytes (Kb) or megabytes (Mb)

Relationships

The shape or proportion of your camera image sensor dictates the final shape of your print. The relationship is the same old problem as that faced by film; 35mm negative differed from the 6 x 6cm film frame or the 6 x 7cm frame. Print proportions offered by photographic laboratories do not always fit in with the sensor proportions of your camera. This presents you with a choice of filling the print area (and losing part of your image) or fitting within the paper size and having a white unprinted area to the edges of the image. We will discuss the methods of printing later on. It is worth holding in your mind the possible proportions that you intend a captured image to be displayed at. This is all part of the creative process of imaging and yet another consideration that has to be tucked away at the back of your mind when working with images.

Size matters

Do you remember the advice on camera file sizes? If you want to have detail in an enlarged image you must capture at the highest-quality resolution in the first place.

If you take your digital file to a laboratory for printing they can advise you on the size of output best suited to your particular file size. There is nothing to stop you blowing up a small file but you will spot the poor quality, which will manifest itself in a blocky 'pixellated' image – how often have you spotted images lifted from a website and then printed in a brochure? The expectation that a 72ppi image on screen will survive to reproduce with clarity at 300dpi is misguided and yet seems to be a common misconception. Perhaps there is a natural reticence in recognising such inferior image quality because digital self-sufficiency strokes the 'I did it myself' ego. With no-one to question your work you become your own judge and jury and this may hamper your progress. There is nothing better than constructive criticism to assist your creativity and development.

FINDING THE BEST PIXEL RESOLUTION FOR PRINTING TO A REQUIRED PRINT SIZE

Multiply the length and the width of your intended print size (in inches) by 300 (printing at 300ppi is universally accepted as generating photo-quality output, although you can get away with 240ppi). This formula will give you the pixel resolution (length and width in pixels) that you need to have to print to your required size at photo quality.

- For example, let's assume you want to print an image to 10 x 8in.

- Multiply 10 by 300 and you get 3,000ppi and 8 by 300 to get 2,400ppi.

- Your digital file will need to have a pixel resolution of 3,000 x 2,400 pixels to make a 10 x 8 in print with an output resolution of 300ppi.

- To get a print this size at 300ppi resolution would require a 7.2-megapixel camera.

8" (8 x 300 = 2,400)

10" (10 x 300 = 3,000)

The calculation

2,400 x 3,000
= 7,200,000
= 7.2 megapixels

FINDING THE BEST PIXEL RESOLUTION FOR A MONITOR DISPLAY

Decide the approximate proportional area of the monitor you'd like your image to cover and divide that into the current monitor resolution.

- For example, covering half the monitor's side-to-side viewing area with an image when running a 1,024 x 768 pixel monitor resolution.

- Divide 1,024 by 2 and you get 512 pixels, all that is necessary to cover half the monitor's 1,024-pixel horizontal viewing area.

- Because of a monitor's lower resolution compared with that required by an inkjet print, you can set a resolution of 72ppi or 96ppi – easily achieved by just about all digital cameras.

1,024 (screen width) divided by 2 = 512 pixels

(screen height)
768 pixels

The calculation

512 x 768
=393,216 pixels
= 0.39 megapixels

Image Retouching – Layers

One of the creative freedoms available to you in a photo-editing package such as Adobe Photoshop Elements is the ability to create, duplicate and modify additional layers within your image. When you work with multiple layering for the first time it may help you to visualise the final image as if seen by a rostrum camera poised vertically over a series of stacked images. However 'thick' your sandwich of image layers, the resulting final view is still a 'flattened' 2-D view.

The structure of image layers usually follows the convention of 'the canvas' encompassing the base image area, know as the 'Background' layer, and then as many additional layers as you require above this. You can, as the next section describes, create images that are not possible using the camera alone. In addition, you can use layers to modify the exposure range, adjust contrast and apply filters using adjustment layers.

Firstly, let's use layers to correct the perspective distortions often experienced by photographing a subject from the wrong distance or viewpoint. The example is an image of a castle tower shot at close distance with a wide-angle lens. Looking upwards has created a tapering distortion of the tower and a disturbing angle in which it appears to fall backwards. This distortion could be overcome by using a specialist 'shift lens' on the camera which, when facing squarely and level to the subject, is raised or lowered using a geared movement control to correct the view. For an amateur, the lens is quite expensive to buy considering its limited specialist application. Layering provides the solution.

Original Image

Final Image

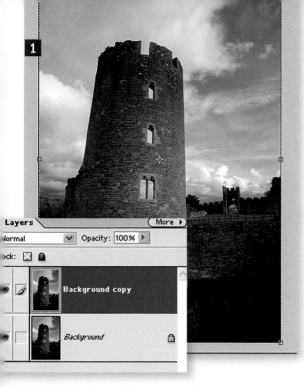

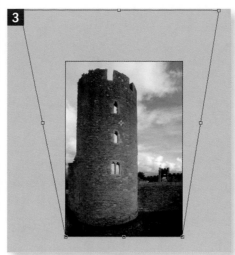

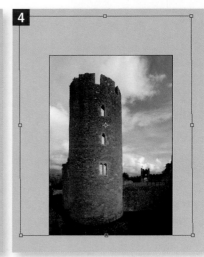

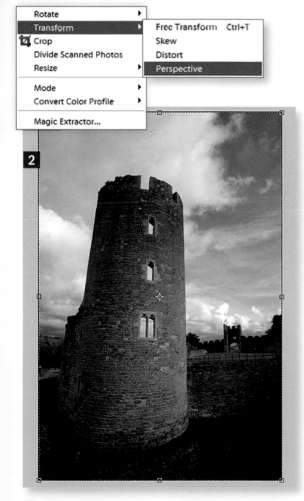

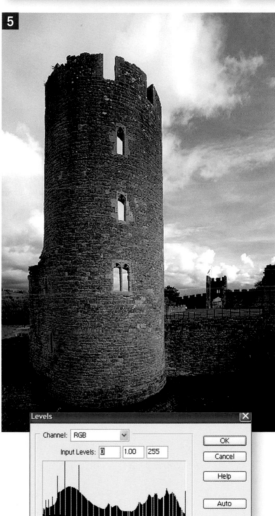

3 The aim is to adjust the tower so that the sides are parallel to the image frame and click OK; at first the new correction makes the building look short and fat, but this can also be adjusted.

4 Now go to Image > Transform > Distort and click on the top-centre box and drag upwards to create a taller (and correctly proportioned) tower. Look at the original layer on the background by clicking the visibility eye next to the duplicate layer and you can see how much improved the picture has become. The tower image is now more powerful and more dominant. Hitting the Enter key will also commit an adjustment.

5 The transformation is nearly complete. All that remains is to adjust the visual appearance of the image by giving the image some 'punch' in the tonal range. Go to Enhance > Adjust Lighting > Levels. The image's histogram is displayed in the resulting Levels dialog window. Slide the two extreme inner and outer cursors to the centre of the panel by a small amount. This clips the tonal range to create a darker 'gutsier' result, which is appropriate for the subject matter in this particular example.

1 First open your image file in your editing application (Adobe Elements is used in this example). In the Layers palette, click on the thumbnail image in the Background layer and drag it to the 'Create a new layer' icon at the bottom of the Layers palette to create a duplicate layer of the original image.

2 Now with the duplicate layer selected in the Layers palette go Image > Transform > Perspective. A square outer frame with tiny boxes at each corner will appear around the image area. Click on the top left-hand corner box with the mouse held down and drag to the left – notice how the right-hand box moves as well. The tower will begin to change shape becoming increasingly squatter.

Creating a Photo Composition

Whenever photo composition is first mentioned by people it is usually in relation to lifting out the head of one figure in a photo and placing it on the shoulders of another figure – usually of the opposite sex (laughter all round). You'd better create one and get that out of your system because creating composites for a purpose is even more fun. Just as taking a photograph requires thought in composition, lighting and execution, the same applies to a composite image. If in your mind's eye you can visualise the appearance of the final image you will know what elements are needed to achieve the end result. Take my example of the aircraft perched high on a supporting column at the entrance to a former airfield.

FINAL IMAGE **Free at last! The static aircraft can fly again thanks to digital imaging.**

ORIGINAL IMAGE **The aircraft was shot at sunrise so the light is both low and rising from the side.**

Knowing that the plane was going to be cut out it was shot filling the frame (to maximise the resolution).

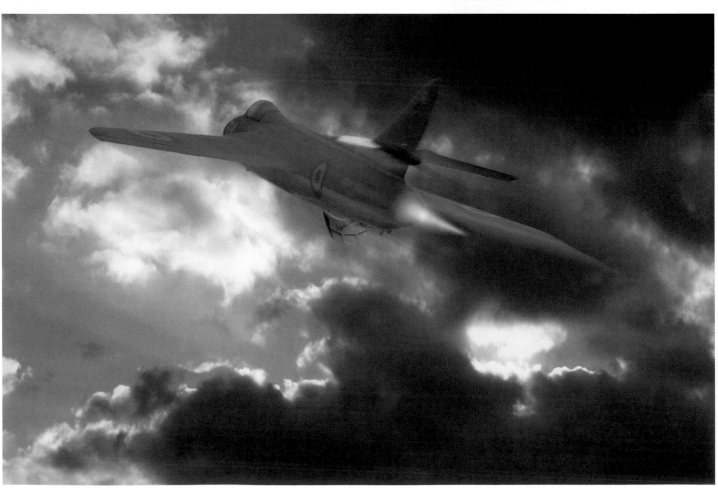

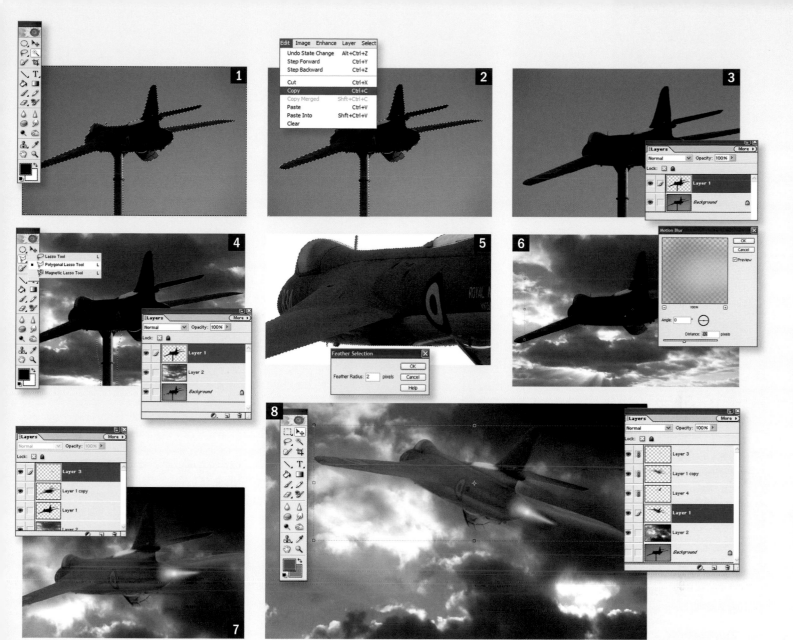

1 Open the image file, and from the Toolbar select the Magic Wand. Click in the sky area to select the background.

2 Hold down the Shift key when using the Magic Wand to add more areas to the initial selection. When all the sky has been selected, go to Select > Inverse – this reverses the selection from the sky to the aircraft. Finish by going to Edit > Copy.

3 Now select Edit > Paste to automatically generate a new layer containing the cutout aircraft, which will sit above the original layer.

4 Open up a file containing a sky image (always useful to have such shots in your library). Click on the image and while holding down the mouse, drag it onto your growing composite. Another new layer will have appeared in the Layers palette. Drag the sky layer down between the cut-out and Background layer. Return to the aircraft cut-out layer and, using the Lasso tool, click around the area of the aircraft support column. When you have completed your selection go to Edit > Cut and the column magically disappears.

5 On the aircraft layer use the Magic Wand to select the open space around it. Go to Select > Modify > Expand and choose 3 pixels. This moves the selection closer and onto the aircraft. Now go to Select > Feather and choose 2 pixels – this expands the area either side of your selection line by 2 pixels. Why are we doing this? Well, now select Edit > Cut and a gentle feather edge to the aircraft is achieved. In reality, no rounded object has a sharp edge to it, what we have just done is to soften the 'visual' join between components.

6 Now, in the Layers palette, drag the aircraft layer's thumbnail onto the 'Create a new layer' icon. Next go to Filters > Blur > Motion Blur and rotate the direction wheel in the Motion Blur window so that the blur follows the lines of the aircraft. Hit OK. With the duplicate layer still selected, reduce the Opacity slider in the Layers palette to allow the main aircraft to show through. The aircraft now appears to be flying past.

7 Click on the 'Create a new layer' icon in the Layers palette, and using the Brush tool select an appropriate mix of colours to create a tail flame. Use the Blur tool to pull the flame to a feathered effect.

8 Create another Motion Blur layer to the tail section using the same technique as before. Now link the four plane layers by clicking in the box next to the visibility eye in the Layers palette so the link icon appears. Go to Image > Rotate > Free Rotate Layer to rotate all the aircraft layers. The composite can now be saved in both its layered form as a PSD file (for future adjustment) or flattened by going to Layer > Flatten image and saved as a Jpeg or Tiff.

Retouching

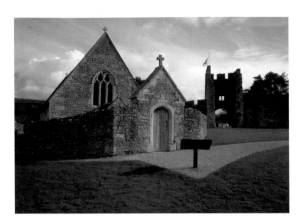

THE ORIGINAL IMAGE **The view past a chapel to castle gate house is marred by an information board – possibly marked 'Keep Off The Grass'.**

However I needed the viewpoint! Under the distant archway are more signs and builders' materials – all this can be retouched away.

Digital imaging provides a second chance to improve on an earlier photograph that might have been taken under less than perfect conditions. Shabby parts of a building can be tidied up, gardens can be populated with colourful flowers – reality can be improved on! To say that a camera never lies always relies on the 'truthfulness' of the photographer who will, of course, put his or her own influence on the result. We have seen that the choice of viewpoint, lens focal length and lighting to capture a moment determines the outcome. Now with the advent of digital imaging we have been given tremendous power to alter and improve. Today it really is hard to believe what you see with your own eyes.

This example shows how to remove modern artefacts from a scene to portray an earlier time.

FINAL IMAGE **By carefully working around the area you can replace missing information, usually from neighbouring parts of the scene. Be mindful of the tonal changes that occur across an image – avoid cloning from a darker or lighter area than the scene you are replacing. In addition, if not used with care, the Clone tool can create a step and repeat pattern that will stand out. It pays to constantly resample the point from which you are cloning to avoid this.**

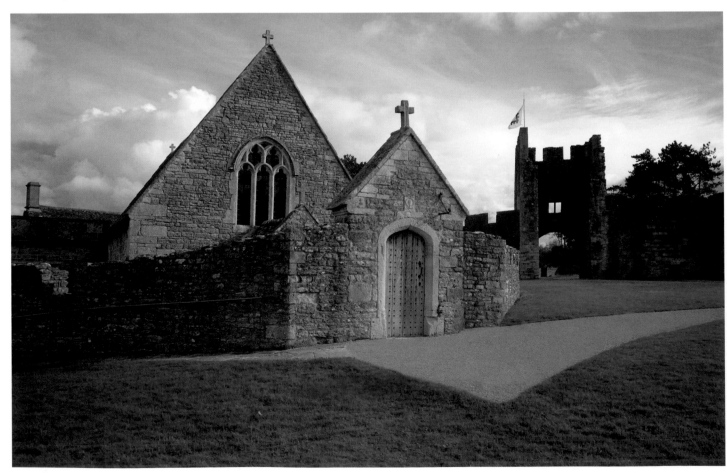

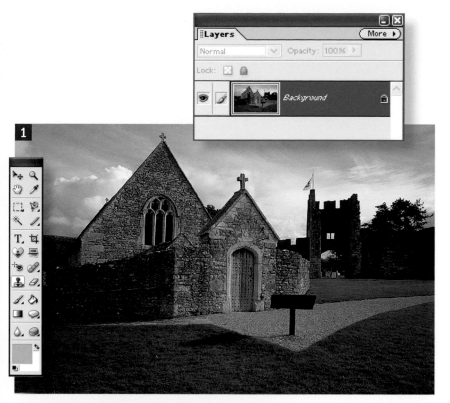

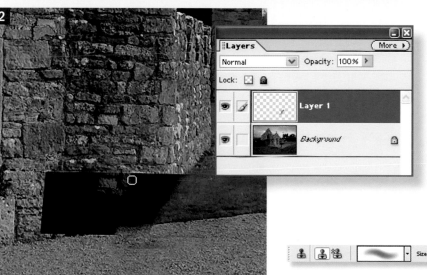

1 Having opened the image in your image-editing application go to the Toolbar and select the Clone tool. To view the image at Actual Pixel size hit Ctrl/Cmd-Alt-0 keys at the same time for a close up view. At this magnification you can easily and comfortably make retouching moves across the image.

2 To begin cloning, move the cursor to an area you wish to use (in this case a clear area of gravel), hold down the Alt key and click the mouse, release the key and now move the cursor to an area you wish to replace with gravel. Now, by moving carefully around with the cursor and clicking the mouse button, you will slowly replace the unwanted sign with the gravel.

3 Pulling out on the view shows you your progress and also shows you areas still to work on. Here you can still see the shadow of the sign in the grass, which needs to be cloned away, along with the signs and objects beneath the archway. The Clone tool can be controlled for brush size, the opacity at which it copies and the mode in which you want to work, by making adjustments in the Tool Options bar.

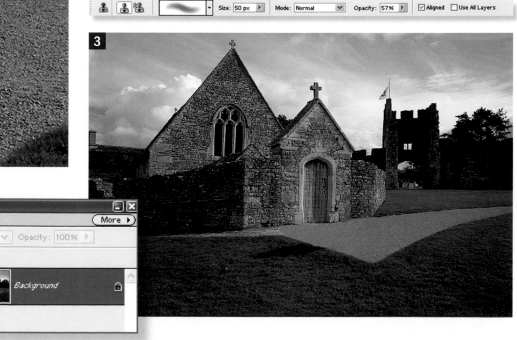

Digital Without a Camera

RIGHT This image is from the late 19th century and was scanned from an old glass plate negative. The firemen sport some marvellous beards and I like the way in which they have chosen to pose themselves. In general the image is pitted, flat and is losing highlight detail – all this, however, can be fixed using editing software.

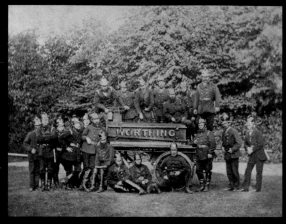

Most of us probably have a collection of old family photographs lurking in a drawer somewhere. Usually the prints will be so faded or scratched that you'll be forgiven for thinking there's not much that can be done with them – think again! Today with a flatbed scanner or even using a high-resolution stills camera you can capture the prints into a digital form and reintroduce some, if not all, of their former vitality and life.

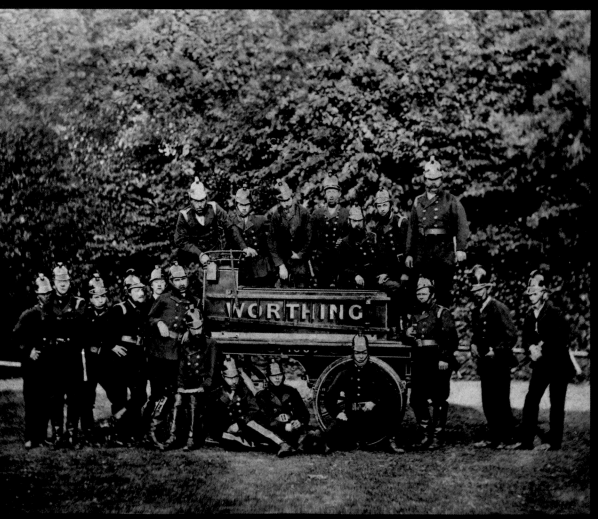

Final image

1 Place your original print onto the scanner's glass. If you're using an image-editing program there'll be a command that allows you to import an image via the scanner. Select this and the scanner will produce a preview of the image. Decide whether to scan as a colour or greyscale image. When seeking to improve the detail of a black and white image scan it as colour. Select a high dots per inch (dpi) setting to scan at in order to maintain good detail, for example around 600 dpi for a 10 x 8inch original. You can downsample the image later once the retouching is complete, but expect large files if you want to see the detail!

Once the scanning is complete it will open in your image-editing software.

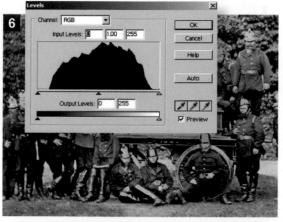

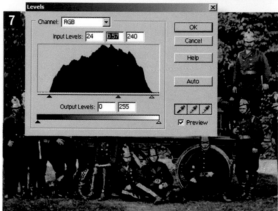

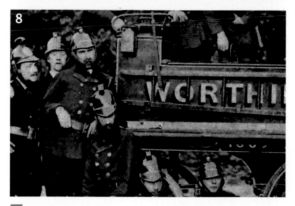

6 The image is successfully retouched for damage, spots and other blemishes. Now it is time to correct the entire image's tone. First create a Levels adjustment layer by clicking the 'Create adjustment layer' icon in the Layers palette and scrolling down to Levels. This will automatically create a new layer and bring up the image's histogram. The image curve is short of the 0–255 range in shadow and highlight. By moving the extreme left and right slider controls inwards to meet the start and finish points of the curve you will extend the image's tonal range.

7 Notice how the contrast has improved – the blacks are punchier and the whites cleaner and brighter. Because this is a Levels adjustment layer correction the adjustment has been made without disturbing the original image. If necessary you can return to the Levels adjustment layer later and fine-tune it.

8 A final check highlights some forgotten scratches which need to be cloned away and the tree at the top left of the photograph requires some stronger retouching. With that complete the task is over and the image can be saved. Go to Layer > Flatten Image and save.

2 Let's fix the damage first using the Clone tool described in the last project. Remember to match as closely as possible the tone of the area you are replacing.

3 When ready to clone hold down the Alt key.

4 Having selected the cloning point, click the mouse to start replacing the damaged area by moving carefully across the image. It's good practice to set the Clone tool's Opacity to 50% in the Tool Options bar to gently build up the new tone.

5 Although this particular area has been fixed, there are many others to retouch. Take your time and work round the image fixing the damaged areas. You can quickly change the size of the Clone tool by using the '[' and ']' keys.

Printing Your Results
– Colour Management

BELOW **Having captured, retouched and adjusted your image the next stage is getting it into print. Colour management is a necessary discipline if you want consistency in your print results.**

Making your photographs look good in print goes beyond having a 'creative eye' or an impressive camera lens. It is determined by the quality of your captured image file, the choice of paper, the method of output and of course the quality of the printer.

Enthusiastic digital photographers rarely rely on the services of high street developers, they tend instead, to make their own prints. As long as you have a computer, scanner and printer there's not too much that you can't achieve with your own digital images and photographs. However what you might be short of is time, patience and money and this will determine how you tackle your own print output. In the ideal world you press the camera button and someone else gives you a print whose colours match real life. In the digital world, unfortunately, you'll have to do more yourself.

Digital colour theory in a nutshell – 'Why don't my colours match?'

It is worth reviewing the basic facts regarding colour printing. As a rule every input device (such as a camera or scanner) 'sees' colour differently, and every output device (such as a printer or monitor) also has its own colour 'space'. This was equally true with film, where each manufacturer's film behaved differently in the same environment. It is important to know what colour language each component of your image-processing system understands. Sadly, your camera, scanner, monitor, and printer will communicate different colour languages. None of them plot the same actual colour to the same R/G/B value. However, the International Colour Consortium (ICC) has created standard ICC profiles so that devices can communicate colour information. Printer profiles let your image-processing program, such as Photoshop Elements for example, translate what you see on the screen to the printed page as accurately as your printer allows. Image-editing profiles, such as AdobeRGB or sRGB, allow you to capture, edit, save and print ensuring that the colours remain consistent throughout the entire process.

How monitors display colour

Most monitors can display up to 256 shades of each R/G/B (Red, Green, Blue) colour on their screens (although to be really precise, pure cyan and pure yellow can't be displayed accurately). A white (or neutral grey) colour on a monitor is made up of equal parts of Red, Green, and Blue, with bright white consisting of the brightest intensities of each colour (R=255, G=255, B=255). The monitor's darkest black would have the lowest illumination (R=0, G=0, B=0). By mixing the various components provided by the RGB data in every pixel, a colour monitor can display up to 16.7 million colours. You need 8 bits of data to store 256 shades of grey, and there are three colour channels, so 8 bits x 3 RGB channels = 24 bits or 16.7 million colours. Whether you're using a Mac or a Windows-based PC you'll find helpful 'wizards' that will help you set up your monitor.

OUTPUT OPTIONS

The illustrations show the typical output options available to you to produce a digital inkjet photo.

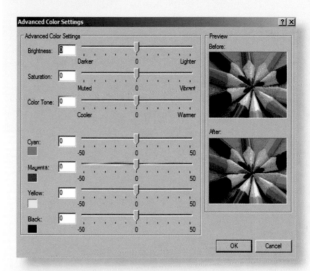

'Trial and error' visual adjustment can be made when printing out an image. Comparing a print with the screen and adjusting the colour saturation and brightness sliders can get the correct results, but test prints will have to be made to fine-tune the settings.

A typical printer control panel allows for several options of print quality, paper type and image placement to name just a few. In addition, system warnings of low ink levels, paper replacement, head cleaning and alignment tools also help keep things under control.

Printers

RIGHT **The Epson Stylus Photo R320 is a versatile inkjet printer with PictBridge capabilities. It can work independently, previewing images on a built-in LCD screen when connected to a camera, or alternatively it can be connected directly to a computer.**

OPPOSITE **The Epson PictureMate printer is a new generation of smaller portable printers designed to fulfil the needs of photographers who require traditional-looking photo prints on demand. The printer is loaded and replenished with packs of media.**

If you wander along the aisles of a large computer store you'll quickly realise that there is an extremely large choice of available printers. As a consequence, deciding on which is the right printer for you can be overwhelming. Hopefully if you haven't already made that decision the following information may help you make up your mind.

What do you want your printer to do?

Assuming that you'll want prints that resemble those that you get from a high-street photo lab, you'll need a colour printer that is capable of printing onto photo-quality paper as opposed to plain paper. So look for the phrase 'photo realistic' or 'photo-quality' when selecting your colour printer. You then need to think about the size of prints you want to make. If you know that you'll only ever want to print postcard-sized images, there are a number of good-quality printers that can do that for you.

Alternatively you may want to print large A3-size prints. Again an increasing number of printers can cope with this size of paper, but they are of course more expensive, and so too is the paper. A sensible third approach is to go for an A4 printer. This is the most popular format for colour photo printers and for this reason they probably provide the best value for money. And of course you can use an A4 printer to print smaller images.

Resolution

Digital cameras use pixels to represent image resolution (measured in pixels per inch – ppi); however, printer resolution is based on the number of dots per inch (dpi) that the printer puts down on paper. The higher the dpi, the smaller the dot size, and thus the harder it is to distinguish one dot from another (under normal viewing). High-resolution, photo-realistic inkjet printers produce micro-sized dots so small that you can only see them under a magnifying glass. Printer resolutions vary from

300 to 2,400dpi and continue to go even higher. As a rule of thumb, if the printer can print to at least 600dpi then you'll be happy with the results.

Remember not to confuse the printer's dpi measure with the output dpi. To obtain good-quality prints you need only set the output dpi in your imaging software to between 240 and 300dpi.

Number of colours

The most common colour inkjet printers print either four or six colours. With four-colour printers there is a separate black ink cartridge used in conjunction with a colour cartridge that contains separate chambers of cyan, magenta, and yellow inks. On their own these three colours are in theory capable of producing almost all the colours in the visible spectrum, but in reality an additional black (k) helps shadow detail and improves the look of dark-toned areas. Six-colour printers have a separate black ink cartridge, but unlike the four-colour printer, the colour cartridge contains an additional light cyan and light magenta that help differentiate subtle tonal changes. There are three-colour printers around which don't feature a separate black cartridge but avoid these as the blacks can look murky.

If you have access to the Internet, you'll find numerous sites that give excellent advice on which specific printers to buy.

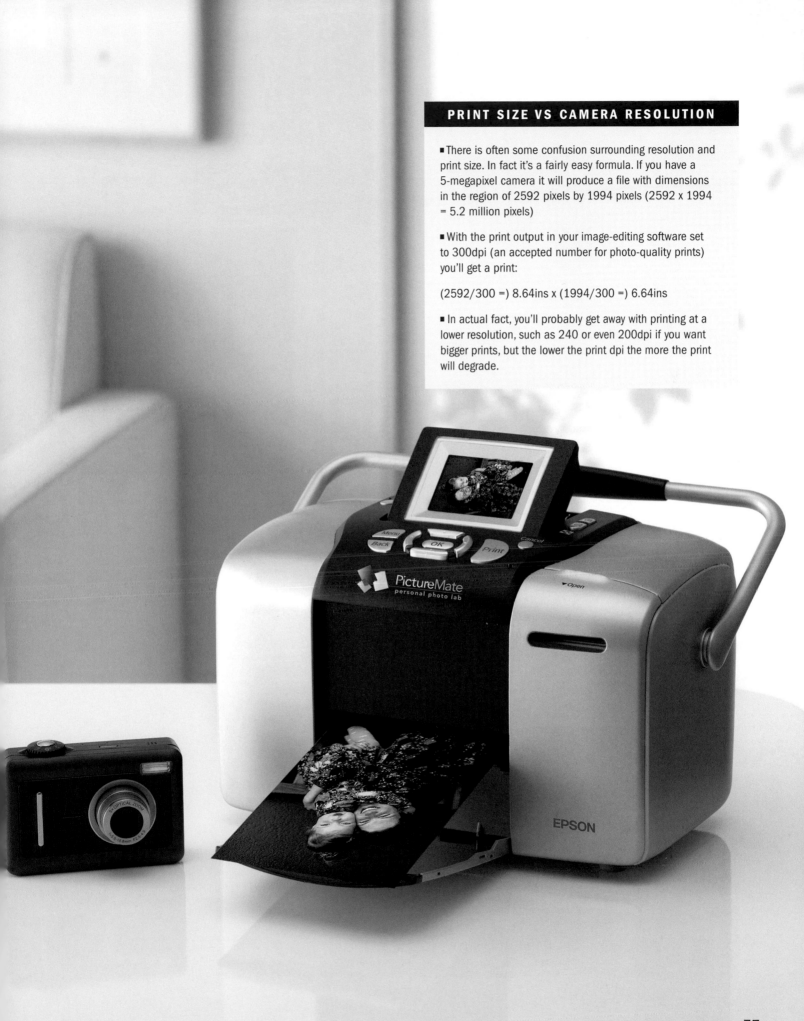

PRINT SIZE VS CAMERA RESOLUTION

■ There is often some confusion surrounding resolution and print size. In fact it's a fairly easy formula. If you have a 5-megapixel camera it will produce a file with dimensions in the region of 2592 pixels by 1994 pixels (2592 x 1994 = 5.2 million pixels)

■ With the print output in your image-editing software set to 300dpi (an accepted number for photo-quality prints) you'll get a print:

(2592/300 =) 8.64ins x (1994/300 =) 6.64ins

■ In actual fact, you'll probably get away with printing at a lower resolution, such as 240 or even 200dpi if you want bigger prints, but the lower the print dpi the more the print will degrade.

Using Print Specialists

U p until now this book has concentrated on the do-it-yourself aspect of digital photography. There are, however, times when you may want to use the services of a professional – and this is most likely to be for printing. While a small 6 x 4in print will pop out of your printer in seconds, an A4 full-colour print will take a little longer to output. If you are after several copies then this will take up more of your time, use more ink, more paper and more money. Running costs tend to be out of our minds when purchasing new printing equipment. These costs, however, soon become a consideration when you are asked to provide multiple copies of full-colour images. Non-branded inks can be purchased for your printer at a cheaper cost but these tend to fade more quickly than branded inks. At times like this it's worth considering third-party printers.

RIGHT **By downloading software from an online laboratory you can use their print services to meet your print requirements – and all from your home desktop! Broadband internet connection is an obvious requirement since you will be handling quite large image files.**

BELOW **In a hurry? Kiosks are becoming increasingly common in retail locations – photo stores, cafes and supermarkets. Just follow on-screen instructions to create an order and collect your prints. Some photo outlets even serve coffee while you wait!**

Photographic options

For example, use your local photo lab to produce large print runs on cheaper photographic paper – remember their quality printers cost thousands of pounds and you'll benefit from their experience and service. All you need to do is burn your edited images onto CD and take it to the lab.

One-off prints needed in a hurry could also be printed using a high-street kiosk system where you choose the print options from an on-screen menu.

Another growing service is online photographic printing, which is available both worldwide from the major photographic companies as well as your local laboratory via their own bespoke software. By simply downloading an interface you can select images from your computer, complete an order, upload the files and within 24 hours have them posted back to you. The advantage here is that from the comfort of your home you can select images, make up an order, and send it out at any time day or night.

More than just a photo

Several companies offer more than just photo prints. You can, for example, have canvas surface prints put onto stretcher frames to hang as wall art. Images can be put onto T-shirts, mugs, place mats even jigsaw puzzles. Some products might be down to a question of personal taste but the message is clear – if you have taken the trouble to create a digital image then give it 'life' by showing it off as a 'hard copy' in print form.

The greatest danger with a digital image is that it's too easy to leave it on a hard drive or memory card because something has to be done to it. Do nothing and it will never be seen. Who knows we might even create a generation of children whose childhood's will not be documented in print form and will not be available to future generations!

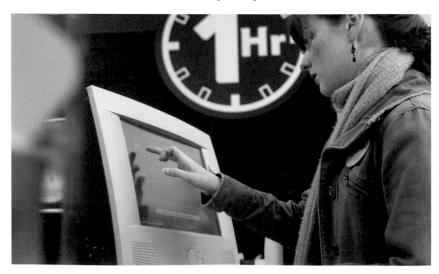

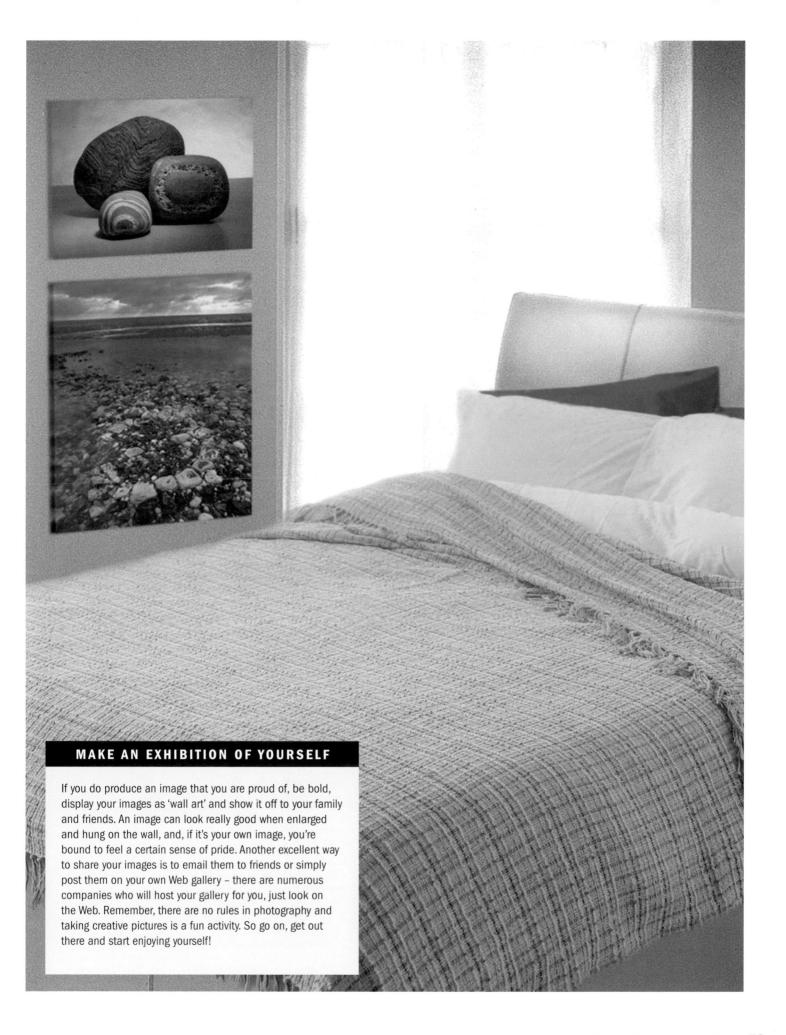

MAKE AN EXHIBITION OF YOURSELF

If you do produce an image that you are proud of, be bold, display your images as 'wall art' and show it off to your family and friends. An image can look really good when enlarged and hung on the wall, and, if it's your own image, you're bound to feel a certain sense of pride. Another excellent way to share your images is to email them to friends or simply post them on your own Web gallery – there are numerous companies who will host your gallery for you, just look on the Web. Remember, there are no rules in photography and taking creative pictures is a fun activity. So go on, get out there and start enjoying yourself!

The Gallery

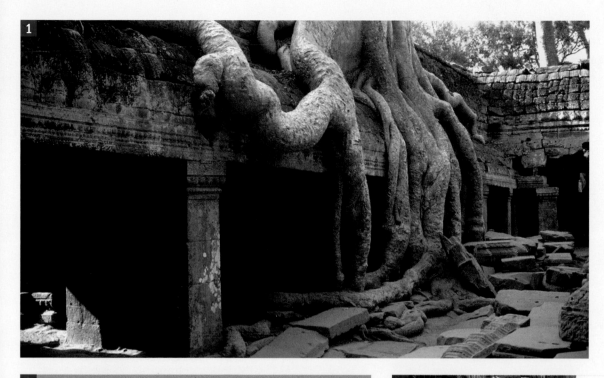

1 An image taken in Cambodia portrays the passage of time that witnessed the engulfing of ancient buildings by these massive tree roots. The cold tones in the shadows contrast with the small chink of sunlight breaking through on the left.

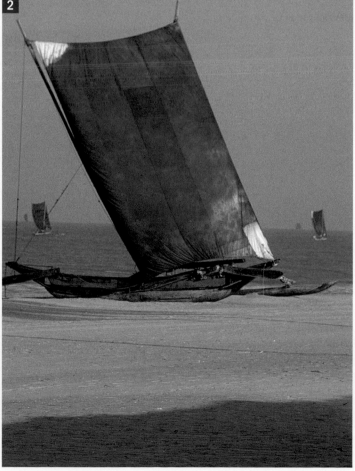

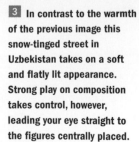

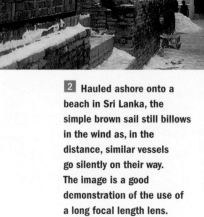

2 Hauled ashore onto a beach in Sri Lanka, the simple brown sail still billows in the wind as, in the distance, similar vessels go silently on their way. The image is a good demonstration of the use of a long focal length lens.

3 In contrast to the warmth of the previous image this snow-tinged street in Uzbekistan takes on a soft and flatly lit appearance. Strong play on composition takes control, however, leading your eye straight to the figures centrally placed.

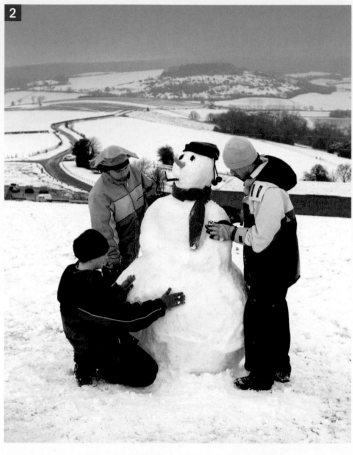

1 This interior shot has been converted to black and white in order to give contrast to an otherwise flatly lit scene. Sometimes the shift into monochrome can produce a much more powerful image than its equivalent coloured version. Steady hands were required on this hand-held interior shot, which was based purely on the available room lighting.

2 If your subjects are happily engrossed in an activity – blissfully unaware of your presence – start taking pictures! These are the best circumstances to photograph your family and saves the 'put that camera away!' comment and those inevitable 'cheesy' grins!

3 The bright colours of the surfer's kite produce a strong eye-catching image. The shot has been framed off centre with the surfer facing away from the camera providing a visual balance. A long focal length telephoto lens would be required to catch any off-shore action, otherwise the surfers would appear inadequately small.

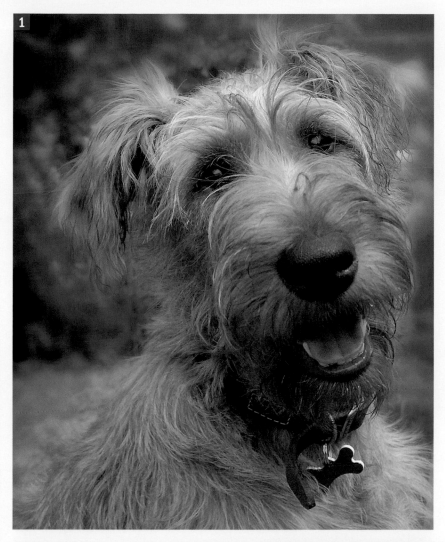

1 Irresistibly charming, this little dog posed for the camera without any coaxing! Using a lens with a focal length of around 135mm allows the background to stay out of focus.

2 This macro (close-up) shot was hand-held, but because of bright sunlight a fast shutter speed of 1/2000th of a second could be used to avoid camera shake. Fill-in lighting came from a reflector held to the side. With close macro work, the built-in camera flash can often be too high and fires over the subject.

3 How to turn a friendly garden spider into a monster! This image was obviously shot towards the sun and as a result, in order to not flare out, the exposure pulls the spider into an eerie silhouette. No chance of fill-in flash either because the exposure (1/2000th @ f/22) was well above the camera's flash synchronisation speed of 1/125th of a second.

1 Brighton Pavilion looking skywards and taken as a detail of the architecture. So often it is the finer detail of a building that sums up the whole; in other words steer away from wide general views and really look for a visual précis instead.

2 Driven by strong compositional angles this image is striking because you the viewer are drawn by the dynamic lines up to the sky. Note the inclusion of a burst of sunlight used as a form of visual punctuation.

3 The calmness of this building is amplified visually by the mirror-like serenity of its reflection in the foreground water. The walking figures (providing scale) are captured at the point just before they move from the lit area to get lost in the shadows of the building.

1 A magical moment over which we have no control. High on a snowy hill the sun appears low from behind the clouds to begin setting. The light changes from its blue hue to purple tinges, the sheep continue to feed... and you have a camera!

2 Notice just how low the horizon has been placed in this image. It breaks the rule of thirds, I know, but it also proves that, in order to emphasise a dramatic sky, there are, as I've said before, no hard rules.

3 Despite its broken branches this tree stands majestically against a setting wintry skyline. To further the dominance of the tree, I shot this from a very low viewpoint and with a wide-angle lens.

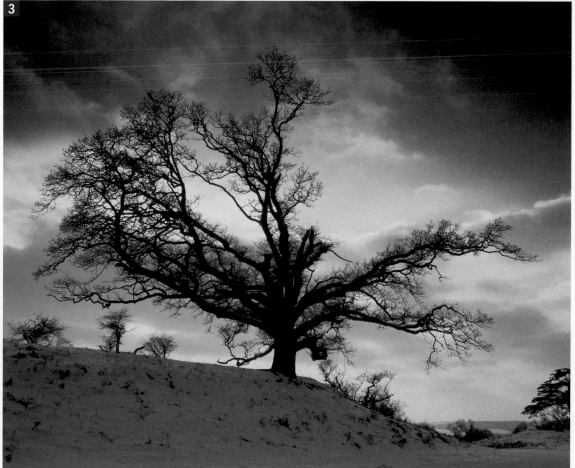

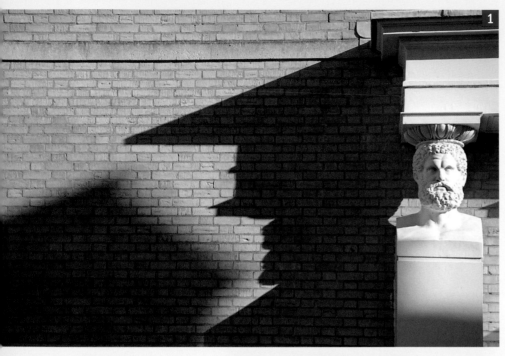

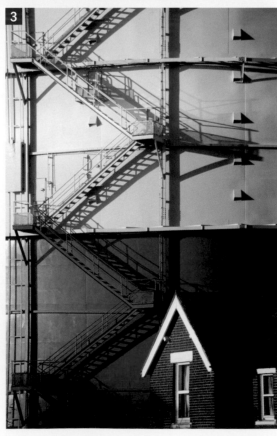

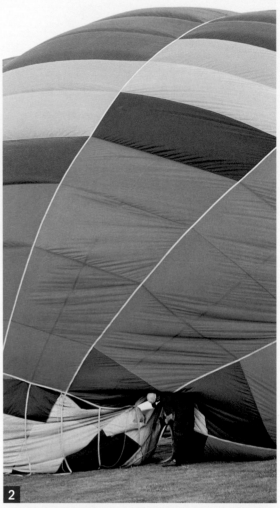

1 Literally 'snapped' while waiting in the street for a friend to arrive, I could not resist the long shadow created by the statue.

2 The figure lifting the fabric provides both scale and a focal point to the vertical composition. The sky helps to reveal the shape of the balloon.

3 The viewpoint for this shot required a long focal length lens and a clear unobstructed view across a busy railway line.

4 This shot of walkers picnicking on a low wall outside an old building summed up their outing. It also creates a sense of scale for the building and they are framed to balance with the offset chimney pot.

1 How low can you go with a setting sun? This shot is probably the limit, the long shadows race across the cut fields and the bales catch the sunlight side on. It is visually so much more interesting than at midday. At this late time of day aerial shots are also at their best.

2 Snowdrops in a spring woodland. Taking a low viewpoint places the viewer in amongst the flowers and also reduces the open spaces between plants to create a carpet of colour. Notice that I have framed the view on the yellow 'infiltrators' who have popped up amongst the white petals.

3 This sandy Chilean landscape has been captured while the sun is side-on and low. The warm variations in the coloured sands and rocks produce a pleasing landscape whose colours contrast against the deep blue sky.

1 I'm at it again, straight into the sun. This image has had a blue graduated coloured filter placed over the lens, helping to reduce the amount of light entering the lens and also to spread the tails of light to a flare. The lens is set to wide angle so as both to get in close and to capture the high sun.

2 This image of a waterfall in Ethiopia shows the natural effect of a rainbow created by the airborne water droplets thrown up from the water below. A demonstration of a photographer seizing the opportunity and framing a shot around the effect.

3 Sunrise in a church graveyard. The early light is tinged with colours that an auto colour correction In software or camera balance could destroy. Always check that you are in control of the outcome by overriding to manual in such circumstances.

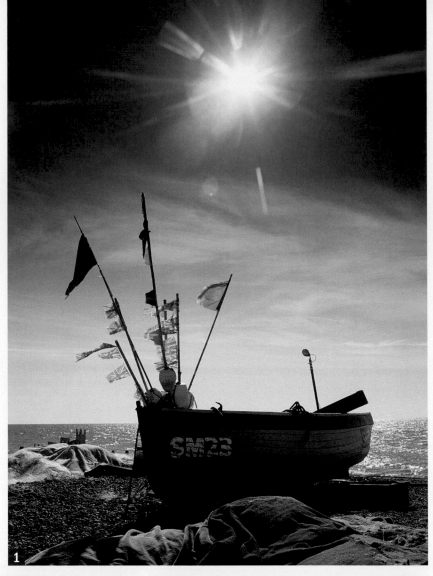

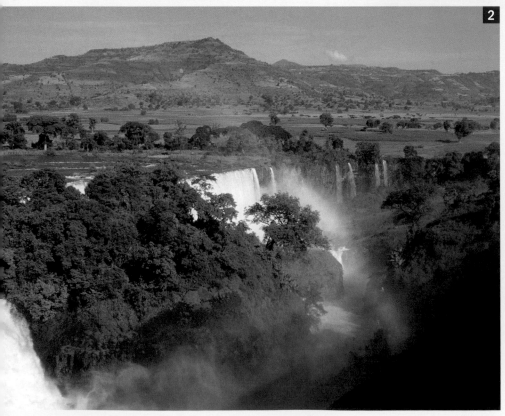

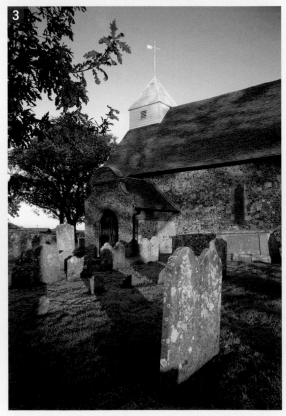

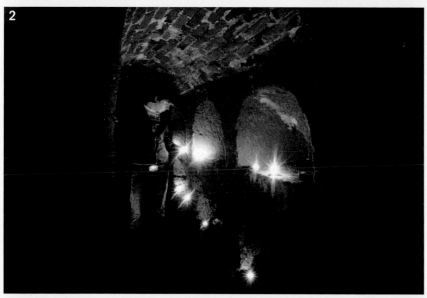

1 There is no getting away from it, for a shot like this you really will need a tripod to support the camera. This exposure was 10 seconds long during which time cars passed by in either direction painting red and white glow lines from their lights. ISO setting at 400, with 10 seconds exposure.

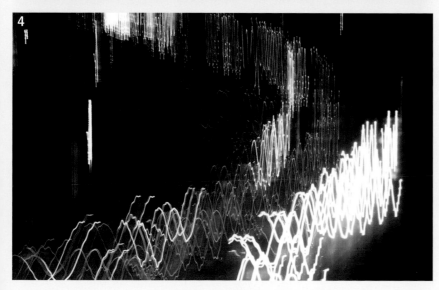

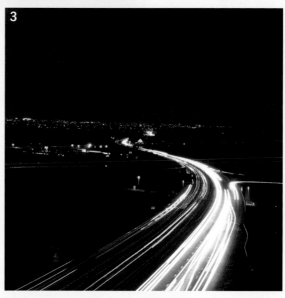

2 With only candlelight the camera was set to ISO 800 and 15 seconds exposure time. Result, a grainy shot with camera noise – it is also, however, a means to an end. Select ISO settings like the gears on a car, low ISO settings of 100–200 (in bright light) for a smooth ride and grainless pictures, high ISO ratings of 400–800 (in low light) when you need to get there, no matter what!

3 Quite literally painting with light. The supported camera is set to 10 seconds exposure ISO 400 whilst motorway cars rush by wiping their coloured lights across the image. The distant orange glow in the sky is created by street lamps.

4 The same circumstances as the shot in 3, but with a creative slant! By raising and lowering the camera consistently during the long exposure, a cyclical wave effect is created.

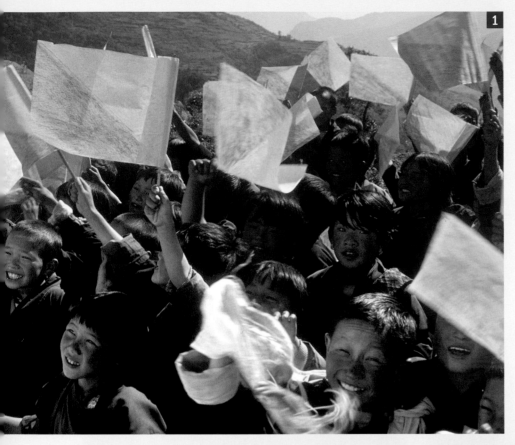

1 In close, the photographer has captured the excited faces of children in Bhutan. Rapid movement of waving hands is partially blurred for effect by choosing a modestly slow shutter speed.

2 A high viewpoint shot against the light creates a gentle outdoor portrait. By asking a more mature female sitter to raise her head to the camera you can produce a more flattering image of her, especially around the neck and chin. This image had a white card reflector just out of shot to push light into the face.

3 Smiling faces all round in this candid shot taken in Java. By not appearing to people to be intrusive in any way, it is possible to take casual images like this. As a visitor to an overseas country, do respect the local customs in order to avoid unwittingly offending anyone.

1 Delicate snowdrops by a mossy tree. The use of a very shallow depth of focus helps to isolate the closest plants from the background.

2 Extreme lighting control; the sunlight was passing under a garden doorway and the narrow shaft of light slid across these nettle leaves. A shot that would easily be overlooked unless you develop an eye for a picture.

3 4 Images of flower heads in close-up almost speak for themselves. Certainly the use of a shallow depth of focus helps to isolate the stamens of the larger flower head and show off its delicacy. The stark vivid colour of the gerbera is a visual statement that would look fantastic on a large canvas image.

1 This page shows three images portraying speed but in different ways. The motorcycle is travelling at a very high speed – it can only be captured by panning the camera with the bike before, during and after the shutter release has been pressed.

2 The plane was not moving at all! Its movement has been created by post production in Photoshop Elements using the Motion Blur tool.

3 By cropping the image long and thin the idea of a race track is created. The emphasis is different from the bike because I wanted the crowd to be seen first and then the car. So, no panning of the camera but an anticipation of when to press the shutter before the car leaves the frame.

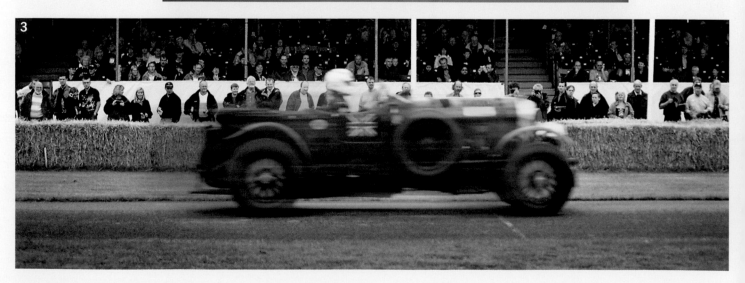

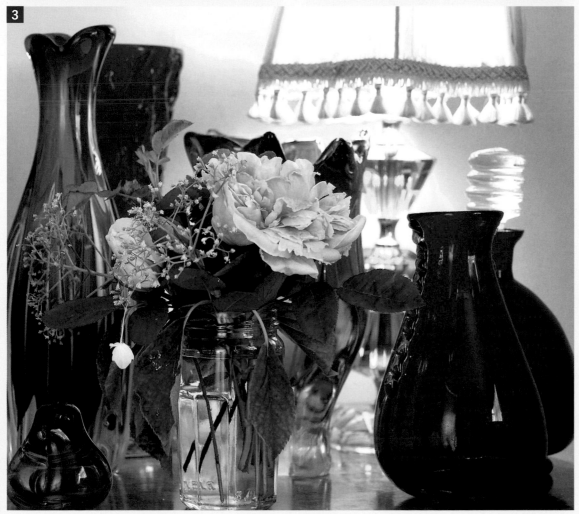

1 Still life is an innocent hobby, you simply shut yourself away with a range of objects and try to find different ways of portraying them. The side effects are that you'll be standing in a hardware shop staring straight up the spout of a watering-can and getting strange looks from the shop owner.

2 Grouping two or three items together with soft day lighting can be the catalyst for a whole range of self-produced greetings cards to your friends. The beach is a good source of subject matter – from shells to driftwood you'll be bound to find something to bring home and photograph. I wasn't referring to the life guard!

3 Feeling a bit too dreary in your choice of still life subject matter? No problem – try and group some really strong colours together, find a theme and see what you can produce.

A Few Common Digital Photography Terms

ANTI-ALIASING Imaging technique in which hard edges of an image are smoothed by blending colours. The effect is most noticeable when applied to text.

APERTURE The camera's adjustable opening that permits light to fall on the camera's sensor or film.

ARTEFACT Appearance of unwanted distortions or clusters of incorrectly coloured pixels in an image usually caused by image compression or the use of a high ISO setting coupled with a long exposure.

BIT The term for the smallest unit of computer memory – it is short for binary digit.

BIT DEPTH OR COLOR DEPTH The number colours or shades of grey each pixel in an image is able to represent.

BITMAP IMAGE Images that are captured as a grid of coloured dots. All digital photography images are bitmap images.

BLOOMING A distortion caused by heavily backlit subjects such as leaves shot against the sky.

BLUR Observed as a lack of sharpness, missed focus, or camera /subject movement created during a slow shutter speed.

BRACKETING Exposing two or three extra shots either side of the correct exposure to ensure the optimum exposure is achieved.

BRIGHTNESS Visual perception of colour rendering. In digital imaging the higher the brightness value, the closer the colour will be to white.

BURN Traditionally a photographic darkroom technique for darkening a selected area of a picture. The burn tool in image-editing software emulates the same process.

CHROMATIC ABERRATION Fringes of magenta seen along the edges of backlit subjects such as trees and buildings. Chromatic aberrations happen if the lens can't focus the different wavelengths of light to the same point on the image sensor.

CMYK Four process colours: they are cyan, magenta, yellow, and black (key). The colours are mixed together to create a full-colour image on a printer.

COLOUR BANDING Visible bands of colours that replace subtle gradations. Banding can occur due to an insufficient colour palette.

COLOUR MODEL A system of classification for individual colours, e.g.: RGB, CMYK

COMPOSITION The control and placement of subjects within the image frame to produce a pleasing and artistic result.

COMPRESSION Term to describe the various ways in which image data is reduced in order to create a smaller file size. Compression that results in the loss of image data every time the image is saved is called 'lossy'. The Jpeg is a lossy file format. Compression that does not require the loss of data is called 'lossless'. The Tiff is an example of a lossless file format.

CONTRAST Measurement of the brightness rate values that change in the image.

DEPTH OF FIELD Reference to the distance between the near and far sharp or in-focus parts of an image.

DIGITAL ZOOM A form of zoom that works by cropping and interpolating an image within the camera. Digital zoom results in a blurry and pixelated image, and its use should be avoided.

DITHERING Mixing existing colours to create an illusion of another colour not available in a given palette.

DODGE Traditional darkroom technique in which a small area of the picture is made less dark by a reduced exposure. The dodge tool in image-editing software performs a similar function.

DPI (dots per inch) The resolution or density of dots within a given area of a printed page. This page for example is printed at 300 dpi.

EXPOSURE Determining the amount of light that your camera captures while taking a picture.

FLARE Destructive stray light entering the lens. Usually occurs when shooting directly at a strong light source like the sun or street lamp.

GAMUT Reference to the range of colours that can be captured or displayed by a device.

GIF (graphics interchange format) Common graphic format displayed by Web browsers.

HALFTONE A form of screening used in printing in which continuous shades of colour are simulated while only using four colors: cyan, magenta, yellow, and black (CMYK).

HUE Hue is the dominant wavelength in reflected or emitted light.

INTERPOLATION Mathematical calculation used to recreate pixels based on existing pixel data when scaling an image.

ISO (ASA) SPEED A measure of a camera sensor's sensitivity to light. Digital cameras usually preset ISO sensitivity – best to choose one that allows a range of speed settings.

JPEG (Joint Photographic Experts Group) Jpegs use a compression method that deletes unnecessary image information in order to reduce the file size. Jpegs are best suited for photographs and images that feature fine gradations of tone and colour.

LIGHTNESS See *Luminance*

LOSSLESS COMPRESSION A type of file compression that reduces file size without losing image date. Tiffs and Gifs are common lossless file formats.

LOSSY COMPRESSION File compression resulting in the loss of image data every time the image is saved. Jpeg is a lossy file format.

LUMINANCE The luminance of a colour is similar to its value or brightness, but the two are not the same thing. Effectively colours bleach out as luminance increases and colours darken as luminance decreases.

MACRO Magnification of a subject captured higher than 1:1.

NOISE A form of artefact in which a grain pattern appears in an image often caused by slow shutter speeds and high ISO settings.

PAN Technique used to 'freeze' a moving subject at the time of exposure by 'panning' the camera horizontally.

PANORAMA A series of images stitched together to create a resulting picture that is wider than a normal camera's viewpoint.

PIXEL Short for a picture element. Pixels are the smallest unit of space in a computer image or display.

PIXELISATION The appearance of recognisable square pixels in an image. Pixelisation usually occurs when a bitmap image has been enlarged beyond its optimum size for its given number of pixels.

PNG (Portable Network Graphic) A PNG file is an alternative to the Gif format. A photo-quality image saved as a PNG does not lose image information .

PPI (pixels per inch) The measurement of resolution of an image as it appears on-screen.

RGB Colour model comprising red, green and blue. Computer monitors emit a combination of these colours to create a full color display. Unlike the subtractive CMYK model, with all three RGB colours combined, the result is white light.

RESAMPLE Changing the pixel dimensions of a bitmap image using interpolation.

RESOLUTION Total number and density of pixels available in a bitmap image; measured in pixels per inch (ppi).

SATURATION Given a level of brightness, saturation measures the amount of grey in a colour. Saturation is a 'close relative' of chroma.

SEPIA Old-fashioned tanned look to an image often created as a special effect either within a digital camera or via image-editing software.

SHUTTER SPEED Determines the length of time the camera image sensor or film is exposed to light. The combination of shutter speed and aperture result in the exposure.

TIFF (tag image file format) A popular lossless file format.

TRIPOD Invaluable 'picture saving' support for camera exposure times above 1/15th second.

TRUE COLOUR A 24-bit colour depth. With true colour 16.7 million colours can be displayed.

TWAIN Interface that allows a computer's software to communicate with scanners and digital cameras.

VALUE Describes just how light or dark a colour is. The higher the value of a colour, the closer it will be to white, and the lower the value the closer the colour will be to black.

WHITE BALANCE In digital cameras, settings that ensure the camera's sensor allows for unnatural colour casts created by artificial or strong natural light to ensure a neutral result.

Index

Index

Acknowledgements

The images were created for this book by
Mike Hemsley fbipp at wgphoto.co.uk.

Additional photography

Photographer Derek Gardiner fbipp who kindly
supplied overseas travel images: p.90 (1,2,4),
p.88 (2), p.87 (3), p.84 (3), p.81 (1,2,3).
Photographer Richard Noon for the Motor
sports image supplied p.92 (2).

Thanks to

Mike Cross, Allphotos Ltd., for trusting me
with cameras from stock to photograph.

Models: Cathy, Grace, Helen, Rob and Tom
for their patience and good humour.

Microsoft for software screen illustrations

Adobe Systems for Photoshop
Elements screen illustrations

The press services of Nikon and
Epson for product illustrations

Robert Hemsley for creating Photocall
online print ordering software.

Thomas Hemsley for his mobile
phone and video images.

This book is dedicated to the memory of my Father,

Alan Hemsley

*Whose enthusiasm and support led me
to my passion for photography.*

ABOUT THE AUTHOR

Mike Hemsley is a fellow of the British Institute
of Professional Photographers.

Running his own studio 'Wgphoto' in Worthing,
West Sussex, he works in the field of commercial
/advertising photography. With almost 30 years
experience as a professional photographer, Mike
has gained many national awards for his work –
twice winning 'Photographer of the Year' title and
gaining Bipp Gold, Silver and Bronze trophies.
His current work interests are video,
3D lenticular imaging and illustration.